MACAT

An Analysis of

Leon Festinger's

A Theory of Cognitive Dissonance

Camille Morvan
with
Alexander J. O'Connor

ROUTLEDGE

Published by Macat International Ltd
24:13 Coda Centre, 189 Munster Road, London SW6 6AW.

Distributed exclusively by Routledge
2 Park Square, Milton Park, Abingdon, Oxon OX14 4RN
711 Third Avenue, New York, NY 10017, USA

Routledge is an imprint of the Taylor & Francis Group, an informa business

www.macat.com
info@macat.com

Cataloguing in Publication Data
A catalogue record for this book is available from the British Library.
Library of Congress Cataloguing-in-Publication Data is available upon request.
Cover illustration: Etienne Gilfillan

ISBN 978-1-912303-55-7 (hardback)
ISBN 978-1-912127-81-8 (paperback)
ISBN 978-1-912282-43-2 (e-book)

Notice
The information in this book is designed to orientate readers of the work under analysis,
to elucidate and contextualise its key ideas and themes, and to aid in the development
of critical thinking skills. It is not meant to be used, nor should it be used, as a
substitute for original thinking or in place of original writing or research. References and
notes are provided for informational purposes and their presence does not constitute
endorsement of the information or opinions therein. This book is presented solely for
educational purposes. It is sold on the understanding that the publisher is not engaged
to provide any scholarly advice. The publisher has made every effort to ensure that
this book is accurate and up-to-date, but makes no warranties or representations with
regard to the completeness or reliability of the information it contains. The information
and the opinions provided herein are not guaranteed or warranted to produce particular
results and may not be suitable for students of every ability. The publisher shall not be
liable for any loss, damage or disruption arising from any errors or omissions, or from
the use of this book, including, but not limited to, special, incidental, consequential or
other damages caused, or alleged to have been caused, directly or indirectly, by the
information contained within.

CONTENTS

THE MACAT LIBRARY

The Macat Library is a series of unique academic explorations of seminal works in the humanities and social sciences – books and papers that have had a significant and widely recognised impact on their disciplines. It has been created to serve as much more than just a summary of what lies between the covers of a great book. It illuminates and explores the influences on, ideas of, and impact of that book. Our goal is to offer a learning resource that encourages critical thinking and fosters a better, deeper understanding of important ideas.

Each publication is divided into three Sections: Influences, Ideas, and Impact. Each Section has four Modules. These explore every important facet of the work, and the responses to it.

This Section-Module structure makes a Macat Library book easy to use, but it has another important feature. Because each Macat book is written to the same format, it is possible (and encouraged!) to cross-reference multiple Macat books along the same lines of inquiry or research. This allows the reader to open up interesting interdisciplinary pathways.

To further aid your reading, lists of glossary terms and people mentioned are included at the end of this book (these are indicated by an asterisk [*] throughout) – as well as a list of works cited.

Macat has worked with the University of Cambridge to identify the elements of critical thinking and understand the ways in which six different skills combine to enable effective thinking.
Three allow us to fully understand a problem; three more give us the tools to solve it. Together, these six skills make up the **PACIER** model of critical thinking. They are:

ANALYSIS – understanding how an argument is built
EVALUATION – exploring the strengths and weaknesses of an argument
INTERPRETATION – understanding issues of meaning

CREATIVE THINKING – coming up with new ideas and fresh connections
PROBLEM-SOLVING – producing strong solutions
REASONING – creating strong arguments

To find out more, visit **WWW.MACAT.COM.**

CRITICAL THINKING AND *A THEORY OF COGNITIVE DISSONANCE*

Primary critical thinking skill: CREATIVE THINKING
Secondary critical thinking skill: PROBLEM-SOLVING

Leon Festinger's 1957 *A Theory of Cognitive Dissonance* is a key text in the history of psychology – one that made its author one of the most influential social psychologists of his time. It is also a prime example of how creative thinking and problem solving skills can come together to produce work that changes the way people look at questions for good.

Strong creative thinkers are able to look at things from a new perspective, often to the point of challenging the very frames in which those around them see things. Festinger was such a creative thinker, leading what came to be known as the "cognitive revolution" in social psychology. When Festinger was carrying out his research, the dominant school of thought – behaviorism – focused on outward behaviors and their effects. Festinger, however, turned his attention elsewhere, looking at "cognition:" the mental processes behind behaviors. In the case of "cognitive dissonance", for example, he hypothesized that apparently incomprehensible or illogical behaviors might be caused by a cognitive drive away from dissonance, or internal contradiction. This perspective, however, raised a problem: how to examine and test out cognitive processes. Festinger's book records the results of the psychological experiments he designed to solve that problem. The results helped prove the existence for what is now a fundamental theory in social psychology.

ABOUT THE AUTHOR OF THE ORIGINAL WORK

Leon Festinger was born in New York in 1919 and received his doctorate from the University of Iowa, where he was greatly influenced by the founder of social psychology, Kurt Lewin. A restless and eclectic scientist, Festinger published his most famous and influential works in the 1950s, before moving away from social psychology, first to focus on the visual system, then to what many considered more anthropological concerns. He died in 1989 at the age of 69, and is still regarded as one of the key psychologists of the twentieth century.

ABOUT THE AUTHORS OF THE ANALYSIS

Dr Camille Morvan is a pyschology researcher and founder of the psychological human resources company Goshaba. She has taught at Sciences Po in Paris and at Harvard University, as well as working at the École Normale Supérieure.

Dr Alexander O'Connor did his postgraduate work at the University of California, Berkeley, where he received a PhD for work on social and personality psychology.

ABOUT MACAT

GREAT WORKS FOR CRITICAL THINKING

Macat is focused on making the ideas of the world's great thinkers accessible and comprehensible to everybody, everywhere, in ways that promote the development of enhanced critical thinking skills.

It works with leading academics from the world's top universities to produce new analyses that focus on the ideas and the impact of the most influential works ever written across a wide variety of academic disciplines. Each of the works that sit at the heart of its growing library is an enduring example of great thinking. But by setting them in context – and looking at the influences that shaped their authors, as well as the responses they provoked – Macat encourages readers to look at these classics and game-changers with fresh eyes. Readers learn to think, engage and challenge their ideas, rather than simply accepting them.

'Macat offers an amazing first-of-its-kind tool for interdisciplinary learning and research. Its focus on works that transformed their disciplines and its rigorous approach, drawing on the world's leading experts and educational institutions, opens up a world-class education to anyone.'

Andreas Schleicher
Director for Education and Skills, Organisation for Economic Co-operation and Development

'Macat is taking on some of the major challenges in university education ... They have drawn together a strong team of active academics who are producing teaching materials that are novel in the breadth of their approach.'

Prof Lord Broers,
former Vice-Chancellor of the University of Cambridge

'The Macat vision is exceptionally exciting. It focuses upon new modes of learning which analyse and explain seminal texts which have profoundly influenced world thinking and so social and economic development. It promotes the kind of critical thinking which is essential for any society and economy. This is the learning of the future.'

Rt Hon Charles Clarke, former UK Secretary of State for Education

'The Macat analyses provide immediate access to the critical conversation surrounding the books that have shaped their respective discipline, which will make them an invaluable resource to all of those, students and teachers, working in the field.'

Professor William Tronzo, University of California at San Diego

WAYS IN TO THE TEXT

KEY POINTS

- Leon Festinger was an American social psychologist* —a scholar of the ways in which our mental processes are affected by our social environment—and an early investigator of human cognition* (the mental process of knowing, or perceiving).

- Festinger's text, *A Theory of Cognitive Dissonance*, originally published in 1957, proposes that people need their thoughts and behavior to be consistent, and when those thoughts and behaviors are inconsistent, or "dissonant,"* they are driven to reduce the discomfort that dissonance causes.

- Festinger's theory describes such a wide range of behaviors and experiences that even now, nearly 60 years after publication, the study of cognitive dissonance* continues to grow and impact other disciplines.

Who Was Leon Festinger?

Leon Festinger, the author of *A Theory of Cognitive Dissonance*, was born in Brooklyn, New York in 1919. He conducted his graduate studies at the University of Iowa, then home to the founder of social psychology, Kurt Lewin.* Lewin became the primary mentor to Festinger, influencing his later research. Michael S. Gazzaniga,* a neuroscientist*—a scientist of the functioning and structure of the

brain and nervous system—has said of Festinger's relationship with Lewin: "Lewin was a commanding figure in psychology and, to hear Leon tell it, one adept at generating new frameworks for studying psychological mechanisms. Leon had read Lewin as an undergraduate and was drawn to his ideas."[1]

Festinger soon developed an interest in studying *cognition*—the mental processes and abilities associated with knowledge. Such an approach challenged psychology's dominant theory at the time, behaviorism,* according to which the study of internal mental states and processes such as cognition had no place in science. (Behaviorist methods were founded on the study of observable behavior.) But by 1957, when Festinger published *A Theory of Cognitive Dissonance*, behaviorism was on the decline, and a so-called cognitive revolution*—a movement towards the study of internal mental states and processes in fields such as psychology, anthropology, and linguistics—was occurring. With it came an emphasis on the theories that Festinger had focused on in his own research.

Though the text is Festinger's most famous, his career included several other influential works. In 1954, for instance, he published *A Theory of Social Comparison Processes*,[2] in which he examined people's drive to have accurate evaluations of their own abilities. He later moved into other areas of psychology such as visual perception,* the process by which we make sense of things we see, and completed his career working with archaeologists.*

Festinger died in 1989. Today he is regarded as one of the key psychologists of the twentieth century. Indeed, a paper published in the *Review of General Psychology* in 2002 placed him fifth in its list of the century's most eminent psychologists.[3]

What Does *Cognitive Dissonance* Say?

Festinger's text begins with the assumption that people prefer consistent cognitions to inconsistent ones. "It has frequently been implied, and

sometimes even pointed out, that the individual strives toward consistency within himself," he writes. "His opinions and attitudes, for example, tend to exist in clusters that are internally consistent."[4]

Thinkers in many fields, Festinger notes, have assumed that humans prefer consistency, and he provides examples of how commonplace these consistent beliefs can be. "A person who believes a college education is a good thing will very likely encourage his children to go to college,"[5] he wrote. But people often have cognitions and behaviors that are inconsistent—or as Festinger calls them, *dissonant*.*

Throughout the text, Festinger uses smoking as an example of dissonant behaviors, noting, "A person may know that smoking is bad for him and yet continue to smoke."[6] This inconsistency, Festinger argues, shows that people are driven to change. Often they may rationalize* the dissonance away—that is, find some kind of logic to excuse it. "The person who continues to smoke, knowing that it is bad for his health, may also feel he enjoys smoking so much it is worth it,"[7] he writes.

However, Festinger argues, people often cannot rationalize away such dissonance, and this gap between their cognitions and their behaviors then causes them psychological discomfort. "When dissonance is present, in addition to trying to reduce it, the person will actively avoid situations and information which would likely increase the dissonance."[8] As the American social psychologist Elliot Aronson* said: "Festinger's theory is about how people strive to make sense of contradictory ideas and lead lives that are, at least in their own minds, consistent and meaningful."[9]

A Theory of Cognitive Dissonance contains many examples and much data from prior studies, often conducted by Festinger and colleagues. This information supports his claim that people often change a cognition or behavior in order to have cognitive consistency.* That volume of data distinguished the text and theory from others. Aronson

noted that the theory "inspired more 3,000 experiments that, taken together have transformed psychologists' understanding of how the human mind works. Cognitive dissonance has even escaped academia and entered popular culture."[10]

The text is influential for several reasons. In making the study of cognition a focal point, it challenged the principles of behaviorism. As one of the first works to do so, it therefore played a key role in starting the cognitive revolution. Its publication did cause controversy, however—primarily over some of the ideas that Festinger had not specifically measured.

For instance, it was unclear from the text whether people experiencing cognitive dissonance did in fact feel psychological discomfort. And if they did, it was also not evident whether that discomfort was directly responsible for the cognition and behavior change that followed. Although this debate is not yet over, the decades of attempts to resolve it have strengthened the theory and produced research that has led to new ideas within the field.

Why Does *Cognitive Dissonance* Matter?

A Theory of Cognitive Dissonance describes one of the most widespread phenomena that social psychologists have ever examined: cognitive dissonance. Festinger argued that dissonance occurs after most decisions. When choosing which one of two cars to buy, for instance, a person must find both options to be attractive if they are seriously considering them. Once a decision is made, Festinger believed that dissonance arises: the car buyer has to live with the fact that he or she did not select one of the alternatives, despite finding it to be an attractive option. Festinger argued that dissonance is possible after nearly every decision where multiple options are possible.

Festinger examined areas other than decision-making,* and numerous researchers—many outside the field of social psychology—have since applied the theory to explain or alter people's behavior. For

instance, in public health, researchers found that making people feel more responsible for inconsistencies between their cognition and behaviors (eating unhealthily despite wanting to be healthy, for example), can improve behavior (in this case, eating behavior). The American social psychologist Joel Cooper* noted that "admitting to prior inconsistent behaviors may induce … dissonance … leading to more positive behaviors toward cancer prevention, the spread of HIV,* and other important health issues."[11]

The presence of the term cognitive dissonance in public discourse demonstrates how widespread the phenomenon is. People are aware of it because they are likely to have experienced it. There are numerous articles and opinions online that apply cognitive dissonance to "real-life" issues such freedom of speech, religion, politics, and public health.

NOTES

1 Michael S. Gazzaniga, "Leon Festinger: Lunch with Leon," *Perspectives on Psychological Science* 1, no. 1 (2006): 89.

2 Leon Festinger, "A Theory of Social Comparison Processes," *Human Relations 7*, no. 2 (1954): 117–40.

3 Steven Haggbloom, Renee Warnick, Jason E. Warnick, Vinessa K. Jones, Gary L. Yarbrough, Tenea M. Russell, Chris M. Borecky, "The 100 Most Eminent Psychologists of the 20th Century," *Review of General Psychology* 6, no. 2 (2002): 139–52.

4 Leon Festinger, *A Theory of Cognitive Dissonance*, Vol. 2. (Stanford, CA: Stanford University Press, 1962), 1.

5 Festinger, *Cognitive Dissonance*, 1.

6 Festinger, *Cognitive Dissonance*, 2.

7 Festinger, *Cognitive Dissonance*, 2.

8 Festinger, *Cognitive Dissonance*, 3.

9 Carol Tavris and Elliot Aronson, *Mistakes Were Made (But Not By Me): Why We Justify Foolish Beliefs, Bad Decisions, and Hurtful Acts* (Orlando, FL: Houghton Mifflin Harcourt, 2008) 14.

10 Tarvis and Aronson, *Mistakes*, 14.

11 Joel Cooper, *Cognitive Dissonance: 50 Years of a Classic Theory* (New York: Sage, 2007), 180.

SECTION 1
INFLUENCES

MODULE 1
THE AUTHOR AND THE HISTORICAL CONTEXT

KEY POINTS

- The text is the original, full account of Leon Festinger's theory of cognitive dissonance,* one of the most widely studied and accepted topics in the field of social psychology* (the study of the ways in which the social environment alters human mental processes).

- The founder of social psychology, Kurt Lewin,* mentored Festinger.

- The relative peace in the US and Europe in the 1950s allowed psychologists to study different processes from those they studied during wartime.

Why Read this Text?

Cognitive dissonance, the theme central to Leon Festinger's *Theory of Cognitive Dissonance* (1957), was a major development in the field of social psychology.

Reaction to the text has spurred decades of research. The noted social psychologist Joel Cooper* wrote in 2007 that "cognitive dissonance is a theory that has had an amazing fifty-year run. … It generated excitement and anger—two elements that frequently lead to controversy, new data, and eventually to a synthesis."[1] Cooper also noted how the theory has entered academic and public discussion: "The theory continues to generate exciting new data in our journals and conference presentations, and animates our classroom lectures. It has become a commonly used phrase in the popular press, frequently making its way into the pages of *The New York Times*."[2]

> 66 Festinger went on to become the dominant figure in social psychology for a period roughly spanning the two decades from 1950 to 1970. 99
>
> Edward E. Jones, *The Handbook of Social Psychology*

In the text, Festinger applies the theory to numerous situations—for example, as an explanation of how people react to difficult decisions, how they seek out new information, and how they interact with the people around them. The scope of the theory, the number of situations it can be applied to, and the fact that it has found its way into other disciplines have made it highly influential. As Cooper said, "it is not surprising that the theory has been used as an analytic tool outside the laboratory to try to understand some of the causes of major world events from politics to terror."[3]

Author's Life

Festinger was born in 1919, in Brooklyn, New York, to Russian immigrant parents. He attended New York City College during the severe economic downturn of the late 1920s and 1930s known as the Great Depression* and he conducted his graduate studies at the University of Iowa, where he worked with Kurt Lewin, the founder of social psychology.

In 1945, Festinger followed Lewin to Massachusetts Institute of Technology (MIT), becoming assistant professor of psychology. He remained at MIT for only three years, leaving shortly after Lewin's death in 1947. Nonetheless, MIT and his collaborations with Lewin were influential.

According to one of Festinger's students, the social psychologist Stanley Schachter*, in an article in *Biographical Memoirs:** "It was at MIT that Festinger's interests turned to social psychology and he launched a series of studies of social influence and communication

that became a turning point in the field, for they demonstrated that it was possible to work experimentally and with theoretical rigor, on non-banal problems of considerable social and psychological importance."[4]

As Festinger recalled, "The years at MIT seemed to us all to be momentous, ground-breaking, the new beginning of something important."[5] By the early 1950s, he had become well known both within the field of psychology and among the public as a result of his work on social comparison:* the theory that people compare themselves to each other in their attempts to evaluate themselves. Schachter wrote in the article of the acclaim Festinger had received for this work, which "led to [him] receiving the Distinguished Scientist Award of the American Psychological Association in 1959 and to his election to the American Academy of Arts and Sciences in that same year."[6]

His research on cognitive dissonance came only a few years after his work on social comparison, while he was a faculty member at Stanford University. One reason that Festinger has remained so influential is that he studied such a wide range of topics throughout his career. Schachter recalled that "the moment things got dull or he [Festinger] found that he was repeating himself, doing some trivial variation of a spent idea, he changed his interests."[7] In fact, Festinger later left the field of social psychology to study visual perception,* the process by which we interpret what we see, and then archaeology.*

Author's Background
The end of World War II,* and the resulting movement of social scientists from Europe to the United States, set the stage for much of the psychology research of the 1940s and 1950s. "The geographic locus of theory and research was the United States," Cooper wrote, "with much of the energy and enthusiasm coming from scholars who had emigrated from Europe during the build-up to Nazism,*

fascism,* and [World War II]."[8] Kurt Lewin was one of those scholars who immigrated to the US to escape the consequences of the aggressive, right-wing ideologies that were taking hold in Europe at that time.

During World War II, psychologists were often used in the service of the war, or in attempts to explain some of the events of the war. For instance, Cooper wrote of a team of psychologists that "had been examining techniques of persuasion that could convince American citizens to make the sacrifices necessary to allow the US and its allies to pursue [the war] to its conclusion in Japan after the surrender of the Axis powers in Europe."[9] Research topics during World War II were often in the service of the war effort—or at least motivated by an attempt to understand the behaviors of war.

Festinger wrote *A Theory of Cognitive Dissonance* in the mid-1950s and published it in 1957. During this relatively peaceful period, psychologists began examining more general human behaviors, such as communication and social interaction. "During the quiescent 1950s, the emphasis of social psychology was examining the way people functioned in groups and the influence that groups—or simply other individuals—had on an individual citizen,"[10] Cooper wrote.

NOTES

1 Joel Cooper, *Cognitive Dissonance: 50 Years of a Classic Theory* (New York: Sage, 2007), x.

2 Cooper, *50 Years*, x.

3 Cooper, *50 Years*, 157.

4 Stanley Schachter, "Leon Festinger," *Biographical Memoirs 64* (1994): 101.

5 Leon Festinger, "Looking Backward," *Retrospections on Social Psychology* (1980): 237–8.

6 Schachter, *Festinger*, 103.

7 Schachter, *Festinger*, 104.

8 Cooper, *50 Years*, 1.

9 Cooper, *50 Years*, 1.

10 Cooper, *50 Years*, 1.

MODULE 2
ACADEMIC CONTEXT

KEY POINTS

- Behaviorism* was the dominant theory in psychology in the 1950s. It emphasized the study of human behavior, neglecting internal mental states such as cognition,* or the mental capacities and processes associated with knowledge.

- Behaviorism gave way to a cognitive revolution* in the social sciences, notably in the field of social psychology, which emphasized the study of internal mental states.

- Leon Festinger was at the forefront of this cognitive revolution, thanks in part to his professional relationship with the social psychologist Kurt Lewin.*

The Work In Its Context

When Leon Festinger wrote *A Theory of Cognitive Dissonance* in 1957, the dominant theory in psychology was behaviorism, which focused exclusively on environmental factors as a direct cause of human behavior. Behaviorists* believed that actions are the result of conditioned responses* developed through reinforcement.* In other words, people learn because they associate certain rewards or punishments with particular actions. A child completes her homework, for example, because she has learned that she will be rewarded rather than punished by her parents or teachers for doing so.

Behaviorism tended to ignore mental explanations—cognitions, motives, and emotions—as causes of behavior. For the most prominent behaviorist, the American psychologist B. F. Skinner,* only observable behavior was valuable to researchers; he characterized thought and

> **❝** Kurt Lewin... who had fled the Nazis to arrive in
> an America where the psychological establishment,
> though hardly a dictatorship, was ruled by an even more
> dogmatic group, also convinced that it had the Truth,
> called Behaviorists. **❞**
>
> Stanley Schachter, in a biography titled *Leon Festinger*

introspection as irrelevant: "This does not mean ... introspection is a
kind of psychological research, nor does it mean ... that what are felt
or introspectively observed are the causes of the behavior. An organism
behaves as it does because of its current structure, but most of this is
out of reach of introspection. At the moment we must content
ourselves, as the methodological behaviorist insists, with a person's
genetic and environment histories. What are introspectively observed
are certain collateral products of those histories."[1]

Festinger was one of the first to challenge such behaviorist
principles. The American social psychologist Joel Cooper* wrote that,
in the early 1950s, as social scientists began questioning the usefulness
of behaviorism, Festinger "had entered this conceptual dialogue on
the side of those who found it useful to talk about potentially unseen
and perhaps unmeasurable internal states."[2]

In fact, Festinger's academic advisor and mentor Kurt Lewin
researched many topics that countered the principles of behaviorism,
even during behaviorism's heyday. "Lewin's research, prior to
[Festinger's] arrival in Iowa, had laid the groundwork for the
ultimate rejection of the classic laws of [behaviorism],"[3] wrote
Michael S. Gazzaniga*, an American cognitive neuroscientist—that
is, a scientist of the structure and processes of the brain and nervous
system. By the 1950s, work on cognition and other mental states
became acceptable, and as these researches grew, behaviorism's
dominance began to subside.

Overview of the Field

Behaviorism ended up being replaced in the course of what is known as the cognitive revolution. Behaviorist methods avoided the examination of cognition; the cognitive revolution made internal mental states the actual focus of research. The American social psychologist* Edward E. Jones,* writing later, was careful not to blame the earlier lack of research on cognition solely on behaviorism's dominance. "Though the full development of a cognitive approach to social psychology may have been impeded by the conservative traditions of behaviorism and physiological reductionism,* he noted, "the concerns of social psychology inevitably required certain broad assumptions concerning cognitive structure."[4]

That is to say, social psychologists needed a better understanding of cognition before they could examine its relationship with social behavior. Many cognitive psychologists* were influential in providing this understanding and in developing a new model with which to view the inner workings of the mind. Chief among them were Frederic C. Bartlett* during the 1930s and Jerome Bruner* throughout the 1940s and 1950s. Both examined internal states such as cognition, detailing how these states varied among participants and also recognizing that personal experiences might shape cognition. Jones said that Bartlett took "his subjects seriously and was eager to let them tell their own stories in their own vernacular."[5] Although this description may not seem unusual now, it ran counter to the dominant thinking of the time.

Gestalt psychology* was a rival approach common during the height of behaviorism's popularity. As Jones said, "Gestalt psychologists traditionally emphasized perceptual and cognitive structures."[6] This, again, was in opposition to the focus of behaviorism. Although Gestalt, associated with German psychology in particular, was much less influential in the United States, some leading American psychologists, Kurt Lewin among them, found Gestalt approaches more appealing than behaviorist ones.

Academic Influences

Thanks to the weakening of behaviorism and the emergence of new works from cognitive psychology, the mid-1950s were ready for the cognitive revolution. And with Lewin as his primary mentor, Festinger was in a good position to contribute to it.

The work of Frederic C. Bartlett was a major influence on Festinger, notably Bartlett's 1932 text *Remembering*, an early work on cognition which focused primarily on human memory and examined the role that social situations play in altering people's ability to remember. Considering the book's impact on both the cognitive revolution and, subsequently, on Festinger, Jones called the text a "classic," writing that it "may be viewed as a major precursor of contemporary cognitive psychology. It specifically set the stage for studies of the role of motivation and expectancy in perception… and even may be credited with an important role in the development of dissonance theory."[7]

But, without question, Lewin was the strongest influence on Festinger's career. Michael S. Gazzaniga recalled that Festinger was not originally interested in social psychology: "By the time Leon moved to Iowa, though, Lewin's interests had begun to shift toward social psychology. During their years of collaboration, Leon also came to focus on social psychology, even though neither of them had ever received formal training in that area."[8] A symbiotic—integrated and mutually beneficial—relationship developed between the two researchers, with Festinger often following Lewin's lead.

NOTES

1 Burrhus Frederic Skinner, *About Behaviorism* (New York: Vintage, 1974), 16–7.

2 Joel Cooper, *Cognitive Dissonance: 50 Years of a Classic Theory* (New York: Sage, 2007), 43.

3 Gazzaniga, Michael S. "Leon Festinger: Lunch with Leon," *Perspectives on Psychological Science* 1, no.1 (2006): 89.

4 Edward E. Jones, "Major Developments in Social Psychology During the Past Five Decades," *The Handbook of Social Psychology* 1 (1985): 83.

5 Jones, *Developments*, 64.

6 Jones, *Developments*, 67.

7 Jones, *Developments*, 63.

8 Gazzaniga, *Lunch*, 89.

MODULE 3
THE PROBLEM

KEY POINTS

- Researchers assumed that people prefer consistency in their cognitions,* but before Leon Festinger's work, there was no popular theory as to why people had this preference.

- Researchers such as Fritz Heider* were beginning to apply theories of cognitive consistency—that is, theories that we naturally prefer to harmonize thought and behavior—to various psychological situations.

- Festinger accepted the idea of cognitive consistency, but he added an explanation for why people have such a preference. He then applied the idea to a wider range of behaviors than any other researcher.

Core Question

Leon Festinger's *A Theory of Cognitive Dissonance* dealt with cognitions and their interaction with each other and with behaviors. Most thinkers at the time believed that people generally preferred consistency over inconsistency when it came to their cognitions and behaviors. The researcher Edward E. Jones* summarized these ideas: "We want our attitudes and beliefs to support rather than contradict our behavior, and we want our cognitions tied together in a coherent, mutually reinforcing system. Such basic assumptions characterize a variety of consistency theories* that appeared in the 1940s and 1950s."[1]

This was not a new proposal though. As Jones noted: "The idea that people are more comfortable with consistent than with inconsistent cognitions has been proclaimed by many psychologists

> ❝ This was hardly a new idea and, in one form or another, had already been proposed by a number of psychologists now known as 'balance' theorists. ❞
>
> Stanley Schachter, *Leon Festinger*

and philosophers. People are not only rational most of the time but also (as [Sigmund] Freud* especially noted) rationalizers.*"[2]

Indeed, decades earlier, the pioneering Austrian psychotherapist Sigmund Freud had documented the extent to which people will try to achieve consistency in their thoughts. Freud discussed a process he called rationalization,* whereby people adjust their cognitions in order to establish consistency between thoughts and behaviors.

What was missing before Festinger, however, was an explanation of *why* people wanted this consistency. According to Jones, "[What] Festinger did was to consider the motivational implication of those inconsistencies that are from time to time thrust upon us."[3] In other words, in *A Theory of Cognitive Dissonance*, Festinger provides a cognitive reason to explain why people prefer cognitive consistency.

The Participants

Fritz Heider, another psychologist, had earlier examined how cognitions coexist within an individual's mind. He came from the German Gestalt* tradition—an approach to psychology that emphasizes the importance of perception and the structuring of mental process.

The social psychologist Joel Cooper* compared Heider and Festinger's approach to the question, noting, "Like Festinger, Heider believed that people intrinsically dislike inconsistent states. It makes us more comfortable if, for example, we like a particular movie and a friend of ours likes the same movie than if we disagreed with our friend. We are pleased by harmonious balance, which is a concept

similar to consistency."[4] Heider called this "cognitive preference balance theory.*"

Cooper also found differences between the two theorists: "But Festinger and Heider came from vastly different traditions when thinking about people's mental states in a social environment. Heider came from a Gestalt tradition in which certain relationships among objects in the physical world were simply preferred to other relationships."[5] Festinger, however, went about applying these principles to our social world.

Other theorists at the time wrote of the human tendency and preference for cognitive consistency or balance. For instance, the psychologists Charles E. Osgood* and Percy Tannenbaum,* a researcher noted for his work on the social psychology of communication,* published a paper in 1955 on the principle of congruity—the state of being in agreement—in which they said that "changes in evaluation are always in the direction of increased congruity."[6]

Osgood and Tannenbaum were dealing with a specific case of cognitive imbalance in which there is a difference between cognitions over the source of information and the information provided by the source. For instance, in the case of an individual receiving unwelcome information from a respected friend, they argued that the individual is likely to change their opinion of either the friend or the information.

The Contemporary Debate
Though Festinger, Heider, and others relied on different terminology, they all shared the basic idea that people prefer consistency in cognition and behavior. Festinger's approach in *A Theory of Cognitive Dissonance* differs from the others in the way that he studied and applied the theory. His question is: "Why do people prefer consistency?"

Further, he applied the question to a wider range of behaviors than had other researchers. Cooper wrote that, in creating his theory, Festinger drew from Kurt Lewin* and that "in that tradition, people

navigated a world in which there were motivational pushes and pulls; there were underlying psychological forces that drove our behavior. So, it was more natural for Festinger to expound a theory of cognitive consistency based on forces and drives rather than perceptual preferences [Heider's balance theory]."[7]

Festinger, then, introduced the idea that people have a motivation and a desire for consistency. Cooper detailed how this idea led to Festinger's other approach: "And once the concepts of drive and arousal were introduced, it was not a major leap to theorize about magnitude. There can be more drive or less drive, depending on the amount of dissonance that is aroused in a given situation."[8] Festinger's text applied cognitive dissonance to many social and psychological events—another factor that set it apart from other theories on preferences for consistency.

NOTES

1 Edward E. Jones, "Major Developments in Social Psychology During the Past Five Decades," *The Handbook of Social Psychology* 1 (1985): 70.

2 Jones, *Developments*, 70.

3 Jones, *Developments*, 70.

4 Joel Cooper, *Cognitive Dissonance: 50 Years of a Classic Theory* (New York: Sage, 2007), 26.

5 Cooper, *50 Years*, 26.

6 Charles E. Osgood and Percy H. Tannenbaum, "The Principle of Congruity in the Prediction of Attitude Change," *Psychological Review 62*, no. 1 (1955): 42.

7 Cooper, *50 Years*, 27.

8 Cooper, *50 Years*, 27.

MODULE 4
THE AUTHOR'S CONTRIBUTION

KEY POINTS

- Leon Festinger argues that people have a desire to reduce anxiety born of cognitive inconsistency* (something that occurs when parts of the "self" such as thought and behavior are not in harmony). He tries to apply this idea to several situations.

- Cognitive dissonance produces a drive in people to try to reduce the dissonance, Festinger says.

- Although Festinger acknowledges the influence of other scholars who were examining cognitive consistency, he states said his task is to move beyond those theories.

Author's Aims

Leon Festinger did not initially set out to examine the cognitive consistency that eventually became the focus of *A Theory of Cognitive Dissonance*. Instead, he was attempting to integrate work on rumors, mass media, and communication. As the neuroscientist* Michael S. Gazzaniga* recalled, "[Festinger] and his colleagues took on the project, and, to hear him tell it, the seminal observation came from considering a 1934 report about an Indian earthquake." The researchers were confused by the spread of rumors of a worse earthquake to come. "After such a horrendous event," Gazzaniga continued, "why would people want to provoke further anxiety? After Leon and his colleagues thought about it, they finally concluded that it was a coping mechanism that the Indian people had developed to deal with their present anxiety."[1]

Festinger suggested that rumors of another quake helped to justify the fear and grief many of the victims were experiencing. It was this

> ❝ What Festinger did with the idea, however, is an illustration of his almost unique genius. He pushed this idea just about as far as it could go, examining and testing its implications for a breathtaking variety of phenomena. ❞
>
> Stanley Schachter, *Leon Festinger*

interpretation that led him to begin his work on cognitive dissonance*—the discomfort that arises when our cognition (roughly, our thought) is not in harmony with our behavior.

From this point, Festinger began developing a theory that could be applicable to other situations and behaviors: "Once the formulation in terms of dissonance and the reduction of dissonance was made, numerous implications became obvious. Following these implications through soon became the major activity of the project."[2] *A Theory of Cognitive Dissonance* applied the theory to a range of situations and presented data that supported the applications. "One of the important aspects of the theory of dissonance," Festinger wrote, "is its ability to integrate data from seemingly different areas, and this aspect would be largely lost if it were not published in a unitary volume."[3]

Approach

Festinger went much further than to say cognitive consistency was a preference. This distinguished him from others examining the topic. As the social psychologist Joel Cooper* wrote: "Festinger's insistence that cognitive dissonance was like a drive that needed to be reduced implied that people were going to have to find some way of resolving their inconsistencies. People do not just prefer eating over starving; we are driven to eat. Similarly, people who are in the throes of inconsistency in their social life are driven to resolve that inconsistency."[4]

Festinger assumed the reason for this drive towards cognitive

consistency was itself a cognition*—a motivation and drive to avoid the discomfort caused by inconsistency.

Another aspect distinguishing Festinger's approach was his use of the term "cognition." As Cooper wrote: "One of the brilliant innovations of cognitive dissonance theory was its use of a relatively new concept called 'cognition.'"[5] Cooper said that the flexibility of the term enabled Festinger to apply it to more situations than if he had used a more specific mental construct, such as "emotions" or "attitudes." "Using 'cognition,' dissonance theory could refer to many different types of psychological concepts. An action is different from an attitude, which, in turn, is different from an observation of reality. However, each of these has a psychological representation—and that is what is meant by cognition."[6]

Contribution in Context

Early in the text, Festinger says that the idea of a preference for cognitive consistency was not original: "The notions introduced thus far are not entirely new; many similar ones have been suggested. It may be of value to mention two [theories] whose formulation is closest to my own. [Fritz] Heider* ... discusses the relationships among people and among sentiments."[7]

Around the same time the influential Austrian psychologist Fritz Heider was examining a specific preference for cognitive consistency. He wrote that there "exists a tendency to be in harmony with the requirements of the objective order. Thus the situation is balanced ... if [a person] admires the person he likes and likes the person with whom he shares values."[8] Heider's theory was restricted to interpersonal scenarios, whereas Festinger took a more inclusive view of the cognitions that were desired to be consistent. Nonetheless, Festinger notes in his book that the basic principles are the same apart from the terminology: "If one replaces the word 'balanced' with 'consonant'* and 'imbalance' with 'dissonance,'* [statements] by

Heider can be seen to indicate the same process with which our discussion up to now has dealt."[9]

Although other researchers had also proposed models of cognitive consistency, Heider was the best known. Festinger acknowledges some of them in the text, reminding the reader, however, that his purpose is to go beyond those theories. "The task which we are attempting in this book," he says, "is to formulate the theory of dissonance in a precise yet generally applicable form, to draw out its implications to a variety of contexts, and to present data relevant to the theory."[10]

NOTES

1 Michael S. Gazzaniga, "Leon Festinger: Lunch with Leon," *Perspectives on Psychological Science* 1, no. 1 (2006): 90.

2 Leon Festinger, *A Theory of Cognitive Dissonance.* Vol. 2. (Stanford, CA: Stanford University Press, 1962), vii.

3 Festinger, *Cognitive Dissonance*, vii–ix.

4 Joel Cooper, *Cognitive Dissonance: 50 Years of a Classic Theory* (New York: Sage, 2007), 3.

5 Cooper, *50 Years*, 6.

6 Cooper, *50 Years*, 6.

7 Festinger, *Cognitive Dissonance*, 7.

8 Fritz Heider, *The Psychology of Interpersonal Relations*, (London: Psychology Press, 2013), 233.

9 Festinger, *Cognitive Dissonance*, 8.

10 Festinger, *Cognitive Dissonance*, 9.

SECTION 2
IDEAS

MAIN IDEAS

KEY POINTS

- Leon Festinger argues that people prefer their cognitions* (or mental abilities and processes associated with knowledge) to be consonant* (consistent with each other). They are driven to make those abilities and processes consonant if they are not, and the size of the discrepancy determines this drive.

- Festinger argued that when dissonance* exists, people try to reduce or eliminate it, and they have certain methods available to realign cognitions.

- He hoped to provide a theory in *A Theory of Cognitive Dissonance* that was rich enough to explain a wide range of human behaviors.

Key Themes

In *A Theory of Cognitive Dissonance*, Leon Festinger notes that any pair of cognitions can have three relationships. They may be consonant* (in harmony), dissonant* (unharmonious), or irrelevant. People can hold a large number of cognitions, and many exist without any relationship to each other. Festinger says there is not "much to say about such irrelevant relations except to point to their existence. Of primary concern will be those pairs of elements [cognitions] between which relations of consonance or dissonance can exist."[1]

Festinger details the human preference to hold cognitions and behaviors that are consonant (that is, consistent) rather than dissonant (that is, inconsistent): "The individual strives toward consistency within himself. His opinions and attitudes, for example, tend to exist in clusters that are internally consistent."[2] Instances of inconsistencies, or

> ❝ The existence of dissonance gives rise to pressures
> to reduce the dissonance and to avoid increases in
> dissonance. ❞
>
> Leon Festinger, *A Theory of Cognitive Dissonance*

dissonance, are "psychologically uncomfortable," he writes, and "will motivate the person to try to reduce the dissonance and achieve consonance."[3]

He presents two other themes in the text. First, he notes that the amount of discomfort between two dissonant cognitions is not always the same: "All dissonant relations, of course, are not of equal magnitude."[4] According to Festinger, the amount of dissonance is important as it determines how much discomfort one experiences. The greater the discomfort, the more attempts a person will make to reduce it. Festinger writes: "The presence of dissonance gives rise to pressures to reduce or eliminate the dissonance. The strength of the pressures to reduce the dissonance is a function of the magnitude of the dissonance."[5] Not all dissonance is alike, and it varies in strength; the more severe the dissonance, the stronger the pressure to reduce it.

Exploring The Ideas
According to Festinger, two factors influence the level of discomfort resulting from dissonance and the subsequent drive to reduce that discomfort:
- The importance of the cognitions involved
- The ratio of consonant to dissonant cognitions

He outlines three methods that people use to reduce cognitive dissonance:
- They can change one or more of the cognitions or behaviors.
- They can add new cognitions that alter the magnitude of the dissonance.

- They can reduce the importance of the cognitions causing dissonance.

These methods are not always easy, and Festinger counters that "if the various cognitive elements involved had no resistance to change whatsoever, there would never be any lasting dissonances."[6]

Festinger uses an example of a cigarette smoker to illustrate many of his key ideas. For instance, a smoker will have cognitions and behaviors related to smoking, such as finding smoking enjoyable while, at the same time, understanding the health risks caused by smoking. These two cognitions are dissonant. The discomfort that the dissonance causes is determined by its magnitude—a combination of the importance and ratio of the cognitions involved. So if the smoker does not consider his health important, then the dissonance and discomfort will be milder than if he is more concerned with his health.

So how can a smoker reduce this dissonance? Festinger suggests that the smoker may change his cognitions or behaviors, writing that "he might stop smoking. If he no longer smokes, then his cognition of what he does will be consonant with the knowledge that smoking is bad for his health."[7] But quitting smoking is difficult, and the smoker may instead attempt to reduce the magnitude of the dissonance. As Festinger explains, "The total dissonance could be reduced by adding new cognitive elements that are consonant with the fact of smoking … the person might seek out and avidly read any material critical of the research which purported to show that smoking was bad for one's health … At the same time he would avoid reading material that praised this research."[8]

This could decrease the importance of the cognitions causing dissonance with the smoker's behaviors. By questioning the research detailing the health risks of smoking, the cognition that smoking is harmful is weakened, thus decreasing the dissonance and subsequent discomfort.

Still other methods are possible for reducing the magnitude of the dissonance. According to Festinger, "Our smoker, for example, could find out all about accidents and death rates in automobiles. Having then added the cognition that the danger from smoking is negligible compared to the danger he runs driving a car, his dissonance would also have been somewhat reduced."[9]

The thoughts and behaviors of a smoker are only one example of the theory applied. "Although the core of the theory is simple," Festinger says, "it has rather wide implications and applications to a variety of situations which on the surface look very different."[10] He discusses some of these other situations throughout the text.

Language And Expression

Festinger's intention is to provide the foundations of a broad theory that might spur further research on cognitive dissonance, and writes that "there are sufficient data now relevant to the theory to warrant communicating it to others, and sufficient corroboration of the theory to hope that others will also pursue it."[11] He presents this data throughout the text, some of it his own, some from other researchers, and much of it reprinted as tables and graphs.

Festinger's book is accessible to a non-academic audience partly because he defines his key terms early in the text. For example, he says of cognition, "Here and in the remainder of the book, I mean any knowledge, opinion, or belief about the environment, about oneself, of about one's behavior."[12]

The term "cognition" had been used before in the field, but in the book, it is central to a theory. This definition, and Festinger's definition of consonant and dissonant cognitions, was useful for psychologists as well as general readers. Indeed, according to an edited volume on social cognition,* "Festinger used the term "cognition" before it was popular, and he used it in a way that is compatible with modern views of the concept."[13]

Festinger's use of comparisons and behavioral examples also increases the accessibility of the text. He goes beyond his invented smoker to apply the theory to social or political issues, as well as to decision-making* processes like buying a new car.

NOTES

1 Leon Festinger, *A Theory of Cognitive Dissonance*. Vol. 2. (Stanford, CA: Stanford University Press, 1962), 12.

2 Festinger, *Cognitive Dissonance*, 1.

3 Festinger, *Cognitive Dissonance*, 3.

4 Festinger, *Cognitive Dissonance*, 16.

5 Festinger, *Cognitive Dissonance*, 18.

6 Festinger, *Cognitive Dissonance*, 24.

7 Festinger, *Cognitive Dissonance*, 6.

8 Festinger, *Cognitive Dissonance*, 22.

9 Festinger, *Cognitive Dissonance*, 22.

10 Festinger, *Cognitive Dissonance*, 31.

11 Festinger, *Cognitive Dissonance*, ix.

12 Festinger, *Cognitive Dissonance*, 3.

13 Joseph P. Forgas, Kipling D. Williams, and Ladd Wheeler, *The Social Mind: Cognitive and Motivational Aspects of Interpersonal Behavior* (Cambridge, UK: Cambridge University Press, 2003), 73.

MODULE 6
SECONDARY IDEAS

KEY POINTS

- Leon Festinger analyzes a variety of contexts in which the theory of cognitive dissonance* was applicable: in decision-making,* after forced compliance* (where people are made to act against their beliefs), in the acquisition of new information, and in the presence of other people.

- These secondary ideas demonstrate the reach of cognitive dissonance, while also providing additional details on how dissonance forms and is reduced.

- Festinger briefly noted that differences in people's tolerance for dissonance are likely. This is an idea that has perhaps been overlooked.

Other Ideas

Leon Festinger's *A Theory of Cognitive Dissonance* examines the wide range of contexts affected by cognitive dissonance—the discomfort aroused when people have thoughts and behaviors that are inconsistent with each other. He dedicates much of the text to detailing four contexts in which cognitive dissonance is relevant and that can explain common, everyday behaviors.

The first context is in decision-making. Festinger believes that most decisions lead to cognitive dissonance as decisions, by definition, involve at least two options. "After a decision is made," he explains, "something must still be done to handle the unpleasantness of having rejected something which is, after all, attractive."[1]

The second context is in forced compliance*—the forcing of people, often through reward or punishment, to act in opposition

> 66 The material dealt with has ranged all the way from the situation in which an individual finds himself after having made a decision, a purely psychological problem, to a concern with the level of proselyting in certain types of mass movements, a problem which would probably interest sociologists more than psychologists. 99
>
> Leon Festinger, *A Theory of Cognitive Dissonance*

to their beliefs. Festinger writes that when "compliance has been forced by either the offer or reward of the threat of punishment ... there is a non-correspondence between the overt behavior and the private opinion."[2]

In a third context, Festinger examines how cognitive dissonance influences how we get new information. He argues that the desire to avoid dissonance influences what information people seek. "Dissonance-reducing cognition is sought; dissonance-increasing cognition is avoided,"[3] he writes. This is also a strategy for reducing cognitive dissonance more generally.

In the fourth and final context, Festinger describes how cognitive dissonance affects our selection of social groups and our interactions with them: "One of the most effective ways of eliminating dissonance is to discard one set of cognitive elements in favor of another, something which can sometimes only be accomplished if one can find others who agree with the cognitions one wishes to retain and maintain. Processes of social communication are, hence, inextricably interwoven with processes of creation and reduction of dissonance."[4]

Exploring The Ideas

These four contexts serve two purposes in the text. First, they illustrate common situations in which dissonance is likely; second, they show

processes by which dissonance is reduced. In discussing these four contexts in detail, Festinger provides specific examples of dissonance reduction.

The first context is decision-making. Festinger discusses choosing between two options and the post-decision consequences: "Imagine a person who has had to make a choice between going to a concert and accepting a friend's invitation to dinner, both being desirable activities to him. Further, imagine that he accepts the dinner invitation, thus giving up the possibility of hearing the concert."[5] In rejecting an attractive alternative—the concert—uncomfortable dissonance arises. Festinger then applies the reduction methods noted above: "He may attempt to think of every bad thing he can about the concert ... [or] he may try to think of attractive things about the evening he will spend in good social company."[6]

Festinger calls this dissonance-reduction process "changing cognitions." By making the choice more attractive and the rejected option less attractive, the amount of dissonance can be reduced.

Festinger gives many examples of forced compliance. In one, he asks the reader to imagine what would happen if "a man came up to you and said he would give you a million dollars if you publicly stated that you liked reading comic books. Let us assume ... that you believe him and that you do not like reading comic books. Very likely you would publicly announce your preference for comic books, pocket the million dollars, and be quite content."[7] The difference between your public and private attitudes in this case shows forced compliance. But the resulting dissonance would be small: cognition importance influences the amount of dissonance, and attitudes toward comic books are not important.

Regarding the acquisition of new information, Festinger summarizes a study in which smokers and non-smokers were given information about the health risks associated with smoking. "The more people smoked, the more they refused to accept information which would have been dissonant* with smoking and the greater the tendency to have a definite opinion on the matter."[8] This section shows how people control

what new cognitions they add in order to reduce dissonance. People can be given the same information, but they will all consider it differently according to their needs.

Finally, Festinger details the relationship between dissonance and social support. He examines the case of an American cult* of about 30 people in the early 1950s whose leader claimed to have received notice of the planet's destruction from a group of extraterrestrials. When Earth was not destroyed as the cult anticipated, the group had to confront the dissonance between their apocalyptic beliefs and the reality in front of them. Festinger writes that afterwards the group leader claimed that "[God] had saved the world and stayed the flood because of this group and the light and strength they had spread throughout the world that night."[9] Rather than drop their initial beliefs, the group rationalized* a way to have them coexist with the dissonance-inducing realization that the planet had not, in fact, been destroyed.

Overlooked

Festinger's ideas received considerable attention. Relatively overlooked, however, was a point he makes in the final chapter, in which he mentions the likelihood that people differ in the way they experience and react to dissonance: "There are, certainly, individual differences among people in the degree to which … they react to … dissonance. For some people dissonance is an extremely painful and intolerable thing, while there are others who seem to be able to tolerate a large amount of dissonance."[10]

Though he does not elaborate, Festinger assumes individual differences can be assessed, noting, "This variation in 'tolerance for dissonance' would seem to be measurable in at least a rough way."[11] He argues that it should be possible to make behavioral predictions—such as, for example, that people who are less tolerant of dissonance will go to extremes to avoid dissonance-inducing situations. "If such a person, for whom dissonance is extremely painful, attempts to avoid the occurrence of dissonance, one would expect to observe that he tries to avoid making

decisions or even becomes incapable of making decisions."[12]

Only a few attempts in the late 1960s, however, were made to examine Festinger's idea.[13]

NOTES

1 Leon Festinger, *A Theory of Cognitive Dissonance*. Vol. 2. (Stanford, CA: Stanford University Press, 1962), 32.

2 Festinger, *Cognitive Dissonance,* 89.

3 Festinger, *Cognitive Dissonance,* 137.

4 Festinger, *Cognitive Dissonance,* 177.

5 Festinger, *Cognitive Dissonance,* 45.

6 Festinger, *Cognitive Dissonance,* 45.

7 Festinger, *Cognitive Dissonance,* 91.

8 Festinger, *Cognitive Dissonance,* 155.

9 Festinger, *Cognitive Dissonance,* 258.

10 Festinger, *Cognitive Dissonance,* 266–7.

11 Festinger, *Cognitive Dissonance,* 267.

12 Festinger, *Cognitive Dissonance,* 269.

13 Martin F. Hunt and Gerald R. Miller, "Open- and Closed-mindedness, Belief-discrepant Communication Behavior, and Tolerance for Cognitive Inconsistency," *Journal of Personality and Social Psychology* 8, no.1 (1968): 35-37; and O.J. Harvey and Robert Ware. "Personality Differences in Dissonance Resolution," *Journal of Personality and Social Psychology* 7, no. 2 (1967): 227.

ACHIEVEMENT

KEY POINTS

- Leon Festinger successfully develops a theory that could describe a range of behaviors.

- Festinger relies on the study of cognition* and the use of theory to make predictions. These two approaches were becoming increasingly popular in the field of psychology in the 1950s.

- Although Festinger argues that cognitive dissonance is a universal phenomenon, future researchers would question this claim.

Assessing The Argument

In *A Theory of Cognitive Dissonance,* Leon Festinger applied the theory of cognitive consistency* to a wider range of phenomena than any previous researcher. Writing about the text and Festinger in general, the social psychologist Henri Zukier* said, "In building his arguments on the interaction between the laboratory and wider natural contexts, Festinger constantly expanded the range of acceptable evidence."[1]

Festinger distinguished himself as a scholar by how much data he brought to the text. This data came from a wider area than the field was used to—not just from experiments but also from historical reports of events and phenomena, such as an Indian earthquake and a doomsday cult.* The American social psychologist Edward E. Jones* praised the theory's ability to make predictions in a range of situations, writing that the findings "were conceptually replicable in a variety of superficially different domains, they were not self-evident without the theory to house them. ... Although

> ** 66 ** His writings are both the manifesto of experimental social psychology and its most distinguished case-book. **99**
>
> Henri Zukier, *Extending Psychological Frontiers: Selected Works of Leon Festinger*

most of the research was done in the laboratory, there were also many excursions into field settings to check on the empirical utility of the developing theory."[2]

Festinger also adds further dimensions to the theory that differentiate it from the work of the influential psychologist Fritz Heider* and others. For instance, as the American social psychologist Joel Cooper* noted: "One of the features of the concept of cognitive dissonance that makes it different from other theories of inconsistency* is that dissonance has a magnitude."[3] Festinger's detailed discussion of the methods with which people attempt to reduce dissonance also goes beyond what other theories of cognitive consistency offered.

Achievement In Context

A Theory of Cognitive Dissonance was more than just a seminal work on cognitive consistency. It was also an early influence on the cognitive revolution,* which shifted psychology's focus away from behaviorism* and toward cognition. Although behaviorists* ignored cognition,* believing it an internal process unavailable to scientific observation, other researchers came to study it in the mid-1950s. Cognitive constructs—attitudes, motives, and emotions—were known to social psychologists and were gaining attention in the field. But it was Festinger's text that gave cognition a central role in social psychology.*

As Cooper explained: "By focusing on 'pieces of knowledge,' as [Festinger] phrased it, dissonance theory could consider relationships between concepts that, until then, had been treated separately. Attitudes, beliefs, perceptions of the environment, values, and

behaviors all fell under a single rubric and all were grist for the mill to determine the level of consistency or inconsistency."[4]

Researchers in the field of social psychology tended to experiment without much theory, in part as a consequence of behaviorism's insistence that only observable behavior should be included in science. Theories, for the behaviorist, required too much prediction and unobserved effects. Edward E. Jones praised Lewin* and Festinger's focus on theory, writing: "Lewin clearly saw that testing theories of sufficient abstraction in different empirical domains would help to resolve questions of conceptual generality. Festinger became the creative executor of Lewin's metatheoretical* (theories about other theories) state, first with his theory of social comparison processes and then even more clearly with his theory of cognitive dissonance."[5]

Limitations

Festinger intended his theory to apply across times, places, and cultures. He notes that the specific situations and cognitions that cause dissonance may vary across these different elements, but dissonance will exist in all peoples, and everyone who experiences it will want to reduce it. He acknowledges the role that culture and experience plays in determining what is dissonant,* saying, "Remember also that two cognitive elements may be dissonant for a person living in one culture and not for a person living in another, or for a person with one set of experiences and not for a person with another."[6] He provides a simple example: "If a person at a formal dinner uses his hands to pick up a recalcitrant chicken bone, the knowledge of what he is doing is dissonant with the knowledge of formal dinner etiquette... [but] in some other culture these two cognitions might not be dissonant at all."[7] Festinger recognizes that cultural norms could affect subjective assessments of whether cognitions are inconsistent.

Nonetheless, in the 1990s, attempts were made to examine how much people in various cultures experienced dissonance. The idea was

similar to Festinger's notion of individual differences in tolerance for dissonance. But rather than focus on differences within the typical group of American participants, researchers studied differences *between* cultures. Some cultural psychologists argued that the motivation to reduce dissonance was more prominent in individualistic cultures,* such as the United States and Western Europe. Eventually, however, a consensus was reached. As the social psychologist Joel Cooper wrote: "The generic process of cognitive dissonance probably transcends limitations of culture and subcultures … Do we all experience dissonance? After several decades, I think the answer is yes."[8]

NOTES

1 H. Zukier, "Introduction," *Extending Psychological Frontiers: Selected Works of Leon Festinger*, edited by Stanley Schachter and Michael Gazzaniga (New York: Sage, 1989), xvi.

2 Edward E. Jones, "Major Developments in Social Psychology During the Past Five Decades," *The Handbook of Social Psychology* 1 (1985): 71.

3 Joel Cooper, *Cognitive Dissonance: 50 Years of a Classic Theory* (New York: Sage, 2007), 7.

4 Cooper, *50 Years,* 26.

5 Jones, *Developments,* 74.

6 Leon Festinger, *A Theory of Cognitive Dissonance*, Vol. 2. (Stanford, CA: Stanford University Press, 1962) 15.

7 Festinger, *Cognitive Dissonance,* 14.

8 Cooper, *50 Years,* 156.

MODULE 8
PLACE IN THE AUTHOR'S WORK

KEY POINTS

- Much of Leon Festinger's work in social psychology* involved the study of cognition* and how people's motivation led them to change their cognitions.

- *A Theory of Cognitive Dissonance* was the centerpiece of this study. It summarized Festinger's career as a social psychologist.

- As the work proved valuable and productive to other researchers, people came to regard Festinger as one of the field's most influential scholars.

Positioning

Leon Festinger published *A Theory of Cognitive Dissonance* 15 years after completing his PhD, but still at the relatively young age of 38. His work prior to 1945 might not be considered social psychology. Festinger noted that it took him some time to become a social psychologist: "When I came to Iowa, I was not interested in social psychology. Indeed, I had never had a course in social psychology. My graduate education did nothing to cure that. I never had a course at Iowa in social psychology, either."[1] As he began work in social psychology, he quickly rose to the top of the field, thanks largely to his work on social comparison.*

Stanley Schachter,* Festinger's student and biographer, described that work as "a tour de force," in which Festinger "extended his theorizing about beliefs, attitudes, and communication to the evaluation of abilities. With the support of several ingenious experiments, he demonstrated that, as with attitudes, and beliefs, the evaluation of one's abilities was also a socially determined process."[2]

> **66** It was an astonishing intellectual career. Whatever area he touched, he enriched. **99**
>
> Stanley Schachter, *Leon Festinger*

In this study, Festinger asserted that people are driven to evaluate cognitively their own abilities and do so by comparing themselves to others. "It was shortly after publication of this body of work in the 1950s that *Fortune* magazine nominated him as one of America's 10 most promising young scientists."[3] Soon after this, he began his work on dissonance, which continued throughout the 1950s.

After that, he began to study areas beyond social psychology. "He worked during this period on a variety of problems related to eye movements, efference* [the transmission of signals from the central nervous system to the motor system], and the conscious experience of perception, as well as on neurophysiological coding for the perception of color."[4] Later still, in the 1970s, he visited archeological dig sites in an attempt to study the psychology and structure of ancient societies. In 1983, he published the findings and speculations gathered from these sites in his book, *The Human Legacy.*

Integration

Festinger's two most famous works—*A Theory of Social Comparison Processes,* a journal article published in 1954, and *A Theory of Cognitive Dissonance,* published three years later—share some common themes.[5] Both texts focus on people's drive for a more comfortable psychological state. In the case of *Social Comparison*, it is a drive for accurate evaluation of one's own abilities; in the case of *Cognitive Dissonance*, the drive is for cognitive consistency.

Henri Zukier,* a social psychologist noted for his research in social cognition, described the linkage: "A common theme underlies many of Festinger's research programs... [They focus] on the

individual change that follows conflict or social influence. The studies are experiments in calculated tension between alternative or contrary forces, which impel a change in thinking, feeling, or behavior."[6]

Both works also consider cognition to be fundamental to the phenomena they describe. In the case of social comparison,* the process by which we compare ourselves to others for the purposes of self evaluation, the evaluations of the self are cognitions. In Festinger's work on cognitive dissonance, he viewed cognition more broadly. The theory applied to all possible cognition, not just those mental approaches and processes relevant to the self.

In 1959, two years after the publication of *A Theory of Cognitive Dissonance*, Festinger co-wrote an important follow-up paper with the social scientist J. Merrill Carlsmith.* The paper presented evidence that when people complete tasks they find boring and are then paid to recruit someone else to complete the task, participants report enjoying the task more when they are paid less.[7] Festinger and Carlsmith predicted that these people were changing their cognition (believing they liked the boring task) to reduce the dissonance created by their dishonest promotion of the boring task to someone else for low pay. In contrast, convincing someone to complete a boring task for high pay is less dishonest and dissonance-inducing.

Shortly after this research on cognitive dissonance, however, Festinger began to move away from cognition and eventually away from social psychology entirely. As Stanley Schachter observed of Festinger's tendency to shift to different study interests, "Boredom was anathema, and the moment things got dull or he found that he was repeating himself, doing some trivial variation of a spent idea, he changed his interests."[8]

Significance

A Theory of Cognitive Dissonance remains Festinger's most recognized, important, and influential work. In summarizing a 50-year history of

the field of social psychology, social scientist Edward E. Jones* described the text as "generally recognized as Festinger's greatest creative contribution, and research related to dissonance theory dominated the journals of social psychology from the late 1950s to the early 1970s."[9] Zukier, in describing Festinger's work on dissonance, stated it was "conceptually and experimentally ... social psychology's most notable achievement."[10] An attempt to quantify psychology's most eminent scholars of the twentieth century, published in 2002, ranked Festinger fifth and noted he is most often associated with his theory of cognitive dissonance.[11]

The social scientist Joel Cooper* believes that Festinger was a major figure in the field even before the publication of *Cognitive Dissonance*, saying, "[His] work on social comparison theory had already made him an influential figure in social psychology."[12] Nonetheless, Festinger's work on cognitive dissonance cemented his reputation. Attitudes toward the theory have varied over recent decades, however, and the book generated much controversy following its publication. As Festinger was considered the primary origin of the theory, he became the focus of critiques in the years following the text's publication. However, as such controversy subsided, Festinger's reputation was restored.

NOTES

1 Leon Festinger, ed., "Looking Backward," In *Retrospections on Social Psychology* (New York: Oxford University Press, 1980), 237.

2 Stanley Schachter, "Leon Festinger," *Biographical Memoirs* 64 (1994): 103.

3 Schachter, *Festinger,* 103.

4 Schachter, *Festinger,* 104.

5 Leon Festinger, "A Theory of Social Comparison Processes," *Human Relations* 7, no. 2 (1954): 117–40.

6 H. Zukier, "Introduction," *Extending Psychological Frontiers: Selected Works of Leon Festinger*, edited by Stanley Schachter and Michael Gazzaniga (New York: Sage, 1989), xvii.

7 Leon Festinger and James M. Carlsmith, "Cognitive Consequences of Forced Compliance," *The Journal of Abnormal and Social Psychology* 58, no. 2 (1959): 203.

8 Schachter, *Festinger,* 104.

9 Edward E. Jones, "Major Developments in Social Psychology During the Past Five Decades," *The Handbook of Social Psychology* 1 (1985): 69.

10 Zukier, *Introduction,* xxi.

11 Steven J. Haggbloom, et al, "The 100 Most Eminent Psychologists of the 20th Century," *Review of General Psychology* 6, no. 2 (2002): 139–52.

12 Joel Cooper, *Cognitive Dissonance: 50 Years of a Classic Theory* (New York: Sage, 2007), 2.

SECTION 3
IMPACT

THE FIRST RESPONSES

KEY POINTS

- The social scientist Milton Rosenberg* produced evidence that called into question the interpretation of some of the data that Leon Festinger presented.

- Several researchers subsequently found that the lack of freedom among participants in Rosenberg's study explained the differences between his and Festinger's data.

- Refutations were found for such major early critiques, which served to strengthen Festinger's theory.

Criticism

Following Leon Festinger's 1957 publication of *A Theory of Cognitive Dissonance*, several researchers sought alternative explanations for his conclusions. Chief among them was the social psychologist Milton Rosenberg, who responded to the text and the 1959 study by Festinger and J. Merrill Carlsmith,* which had quickly become the leading research into the phenomenon.

Rosenberg conducted a similar study to that of Festinger and Carlsmith. He argued that participants who received the higher payment likely perceived it as a bribe by the experimenters and did not want to appear fickle. Rosenberg found evidence supporting the idea that participants in the study were reacting to the experimenter rather than the reward.

The American psychologist Joel Cooper* summarized Rosenberg's interpretation, noting that Rosenberg had the participants' responses "collected by a completely different experimenter who was in a different room doing a different study. In that way, subjects would not

> ❝ In the wake of an honest controversy, such as the one that swelled around dissonance theory, the ideas, findings, and results that come from attempts to disprove, reinvent and reestablish create a dialectic that culminates in a deeper understanding of the phenomenon. ❞
>
> Joel Cooper, *Cognitive Dissonance: 50 Years of a Classic Theory*

feel that they were having their honesty and integrity assessed by the experimenter and would not hold back their true opinion."[1] For Cooper, Rosenberg's interpretation was the most reasonable of the early criticisms. "Rosenberg's was perhaps the most intriguing explanation, and he supported it with data,"[2] he wrote.

Other researchers were more favorable to Festinger's text and theory, and they tried to extend the theory to fields that he had not considered. For instance, two of Festinger's former students, Elliot Aronson* and Judson Mills,* considered the case of people willingly enduring pain—such as through intense physical training. Such behaviors ought to be inconsistent with a human desire not to suffer, and one might expect to find dissonance. However, Aronson and Mills found that participants engaging in painful or embarrassing tasks would often avoid dissonance by finding ways to justify these tasks.[3]

Responses
Following *A Theory of Cognitive Dissonance*, Festinger produced two notable publications on the topic of cognitive dissonance—first, the 1959 paper with Carlsmith and second, a 1962 article[4] that briefly summarized the theory and incorporated the findings from the 1959 article. In neither of those works, however, did Festinger address any of the criticisms that the theory had received.

It is unclear why Festinger did not engage in a debate with critics, at least in any published forum. Instead it was Festinger's students, among

many other scholars, who responded to Rosenberg and other critics. For instance, Darwyn E. Linder,* Joel Cooper, and Edward E. Jones* found that the distinguishing feature between the studies of Rosenberg and Festinger was the different perception of freedom that the participants held. In Festinger's experiment, the subjects were given the choice of whether or not to participate in the boring task. In Rosenberg's experiment, however, participants were compelled to complete the task.

Cooper recalled "that dissonance* would occur only when the participants believed they had freely chosen [to complete the task]."[5] Festinger had argued that people feel dissonance when they complete a boring task for little reward and then search for a reason to explain why they agreed to the boring task in the first place. Cooper and his colleagues believed that Rosenberg found different effects because he forced his participants to complete the boring task. Feeling *forced* to complete the task actually became the cognition that explained their behavior to themselves. (Imagine participants saying to themselves, "Yes that task was boring, and I completed it for little reward, but I didn't have a choice; the experimenter forced me.") As Cooper put it: "Knowing they had no choice but to behave as they did perfectly explained why they [completed the task]. Dissonance would not be aroused and would not need to be reduced."[6]

Conflict And Consensus

The field reached a consensus over these early criticisms, accepting Festinger's original theory while also agreeing that certain factors could limit the formation of dissonance and discomfort. These factors are known as moderators*—variables that negate or even reverse the typical effects reported with a phenomenon.

Cooper credits these studies by Rosenberg and others as leading to a "search for moderators."[7] In the case of Rosenberg, the moderator was freedom of choice. This particular moderator could be applied to many of the scenarios that Festinger originally discussed.

For instance, with decision-making,* Festinger had noted dissonance as a consequence of making decisions. But if one does not have a genuine choice, dissonance is less likely to arise. Imagine you are admitted to two similar colleges, and you feel similarly excited about the prospect of attending both. However, one is far from home and the other nearby. Your parents insist they will only provide financial support if you attend the nearby college. In this scenario, you might believe you have little freedom to choose between the two colleges, so post-decision you feel no dissonance. (However, if you end up unhappy at the college nearby, a sense of resentment toward your parents may instead arise.)

Later researchers added other moderators. But such moderators have only served to add further context to the theory—factors that prevent dissonance from arising when it otherwise would. What has remained unaffected is Festinger's central principle: when dissonance is present, people seek to reduce it.

NOTES

1 Joel Cooper, *Cognitive Dissonance: 50 Years of a Classic Theory* (New York: Sage, 2007), 30.

2 Cooper, *50 Years*, 29.

3 Elliot Aronson and Judson Mills, "The Effect of Severity of Initiation on Liking for a Group," *The Journal of Abnormal and Social Psychology* 59, no. 2 (1959): 177.

4 Leon Festinger, "Cognitive Dissonance," *Scientific American* 207, no. 4 (1962), 93–107.

5 Cooper, *50 Years*, 34.

6 Cooper, *50 Years*, 34.

7 Cooper, *50 Years*, 35.

THE EVOLVING DEBATE

KEY POINTS

- The American social psychologist Daryl Bem* questioned whether people's cognitions* were adequately clear and developed within their minds for them to determine whether pairs of cognitions are consistent or inconsistent with each other.

- Later researchers disagreed on whether it was cognitive inconsistency* or discomfort that directly caused the change in attitude and behavior typically associated with cognitive dissonance.*

- Although the text and theory of *Theory of Cognitive Dissonance* continue to cause debate, the central principles have been widely accepted and are increasingly applied to fields other than social psychology.*

Uses And Problems

After early critiques of Leon Festinger's *Theory of Cognitive Dissonance* by social psychologists such as Milton Rosenberg,* a new wave of alternative explanations emerged. In particular, Daryl Bem, noted for his research into self perception, applied Festinger's self-perception theory* to help explain the phenomenon of cognitive dissonance. Bem noted that a key part of Festinger's theory was an assumption that people are aware of their cognitions; for people to experience dissonance between two cognitions, those two cognitions need to be clear. But, Bem argued, this assumption was false. Often we do not have clear cognitions or access to those cognitions, he said, and so we rely on our behavior to inform these cognitions.

Bem posed the following example: "When the answer to the

> **❝** A second wave of criticisms took a different tack.
> Rather than arguing that there was something wrong
> with the procedure in dissonance experiments, the next
> round of criticism focused on the theory itself. **❞**
>
> Joel Cooper, *Cognitive Dissonance: 50 Years of a Classic Theory*

question, 'Do you like brown bread?' is 'I guess I do, I'm always eating it' … the reply is functionally equivalent to one his wife might give for him: 'I guess he does, he is always eating it.'"[1] In other words, we might not have an opinion of brown bread, or we might not be aware of it, and so we infer our opinion from our behavior. Bem argued this explains much of the data that Festinger had presented.

The debate between Festinger and Bem's interpretations hinged on an aspect that Festinger had assumed but not yet examined: that dissonance caused discomfort. The social psychologist Joel Cooper* recalled: "For the first decade of research in the theory of cognitive dissonance, there was not much need to worry about whether the proposed state of internal tension was real, or whether it was just a concept whose identifiable tenets created the non-obvious interesting predictions that data ultimately confirmed. With the advent of self-perception theory, it suddenly mattered."[2] In other words, the way to settle the debate between Festinger's and Bem's approaches was to test Festinger's assumption that people did in fact feel discomfort in response to cognitive inconsistency.

Schools Of Thought

In order to decide between Bem's and Festinger's theory, researchers had to prove that the cognition or behavioral change that results from cognitive dissonance was caused by psychological discomfort. Much research in the field from the 1970s to the 1990s was dedicated to this cause.

A common dissonance task during this time was to instruct participants to write an essay that was counter to most American college students' attitudes—specifically an essay in favor of President Gerald Ford's* decision to pardon former US President Richard Nixon.* Nixon had been charged with obstruction of justice and forced to resign in 1974 after being caught up in a grave political scandal called Watergate.* Some studies measured physiological arousal during and after this dissonant* task; others simply asked participants to report how uncomfortable the task made them; still other studies tricked participants into thinking they had been given drugs to make them *believe* they were aroused and uncomfortable.

These techniques all generally found that, indeed, arousal and discomfort are present when people experience dissonant cognitions.

From these findings grew a motivational account of cognitive dissonance. Festinger had always argued that people are driven to reduce dissonance, but he never actually measured the dissonance or the motivation to reduce it. With increasing research finding a direct relationship between discomfort and cognition change, a new school of thought on cognitive dissonance emerged. The psychologists Russell Fazio* and Joel Cooper were the chief supporters of this version. As Cooper wrote: "Dissonance ... has precious little to do with inconsistent cognitions but rather is driven by the perception of unwanted consequences. Festinger's formulation was perhaps more elegant, but it was the anomalies and exceptions that accumulated in the decades of data collection that led us to see that the original formulation was no longer the best explanation for the phenomenon."[3]

Cognitive inconsistency was still seen as important and often was a cause of discomfort, but (according to this school of thought) it was not a necessary factor in driving dissonance reduction.

In Current Scholarship

The debate about cognitive consistency has continued and is still

unresolved. For instance, Eddie Harmon-Jones,* a social psychologist at the University of New South Wales, follows Festinger in arguing that it is cognitive inconsistency rather than discomfort that causes attempts at dissonance. Harmon-Jones recently said that "dissonance [discomfort] and dissonance-related attitude change can occur in situations in which a cognitive inconsistency is present but the production of aversive consequences is not present."[4]

Regardless, supporters of both schools of thought accept most of Festinger's original contribution. Fifty years after Festinger's text, Cooper wrote that "cognitive dissonance theory has been an active field of study for five decades. The phenomenon, once thought controversial, has become widely accepted. Old controversies have ended and new ones have emerged as we continue to understand more about its limits and its underlying process."[5]

The central principles of Festinger's theory—that some combination of cognitive inconsistency and the discomfort that it often aroused lead to attempts to reduce both the dissonance and discomfort—are still a guiding framework for researchers in many fields. The theory has been applied to psychotherapy, weight loss, and other issues of public health.

People typically want to be healthy, for example, yet engage in unhealthy behaviors. Researchers find they can affect behavioral change by reminding participants of their unhealthy behaviors and their personal responsibility for them. This tends to induce dissonance, which in turn motivates people to change their unhealthy behaviors.

NOTES

1 Daryl J. Bem, "Self-perception: An Alternative Interpretation of Cognitive Dissonance Phenomena," *Psychological Review* 74, no. 3 (1967): 186.

2 Joel Cooper, *Cognitive Dissonance: 50 Years of a Classic Theory* (New York: Sage, 2007), 43.

3 Cooper, *50 Years,* 80.

4 Eddie Harmon-Jones and Cindy Harmon-Jones, "Cognitive Dissonance Theory After 50 Years of Development," *Zeitschrift für Sozialpsychologie* 38, no. 1 (2007): 11.

5 Cooper, *50 Years,* 157.

MODULE 11
IMPACT AND INFLUENCE TODAY

KEY POINTS

- *A Theory of Cognitive Dissonance* was a seminal work in the fields of cognition* and social psychology,* and a forerunner of the cognitive revolution.*

- The text still challenges researchers, particularly those who debate the direct cause of the attitude and behavioral change that is associated with cognitive dissonance.*

- Notable researchers who retained some behaviorist beliefs, such as Albert Bandura,* incorporated cognition into their research. Meanwhile, Fritz Heider's* balance theory* (which argues, roughly, that people want to like what their friends like and tend to dislike what their friends dislike) remains influential, particularly for marketing researchers.

Position

Leon Festinger's *A Theory of Cognitive Dissonance* remains historically relevant. It was one of the early texts to place cognition at the center of its research approach. It was also influential in the cognitive revolution—the turn towards research into cognitive processes in fields such as psychology, anthropology, and linguistics.

Social psychologist Joel Cooper* noted: "Cognitive dissonance has already left many legacies in its wake, and there will almost certainly be more. Its legacies have been both practical and theoretical. At the theoretical level, cognitive dissonance helped us to see the limits of certain other principles that had been thought to be ubiquitously universal, such as reinforcement* and learning theories.*"[1]

Cooper mentioned two principles of behaviorism.* "Reinforcement" refers to a consequence (getting good grades, for

> ❝ Festinger would have been pleased to see his theory mature, to see it cast off some of the assumptions that were contradicted in the empirical realm and replaced by more comprehensive views. ❞
>
> Joel Cooper, *Cognitive dissonance: 50 Years of a Classic Theory*

example) that strengthens an association between behavior (say, studying), and a stimulus or cause (knowing a test is coming). "Learning theories," in this context, refer to the various theories of learning that behaviorists subscribed to. Few texts were as influential as *Cognitive Dissonance* in moving the field from these principles to those of attitudes, motives, and emotions.

Festinger's text and theory generated decades of research and debate. Through that work, several new theories were born—some in support of the theory, some in opposition to it. Cooper considered this possibly the theory's most important contribution, saying, "Cognitive dissonance has informed, and been informed by, a host of other theories."[1] Among these are theories about the role of motivation in cognition and behavior change, in particular Daryl Bem's* self-perception theory.*

Festinger was also responsible for ushering in a new, creative, and experimental methodology with an eye to applying psychological research to real-world issues, according to Cooper. In his words, "Cognitive dissonance research added methodological innovations to social psychology, including an emphasis on high-impact research in which meaningful and elaborate social situations were made very real to participants in experimental settings."[3]

Interaction

As the cognitive revolution took hold in the 1960s and 1970s, behaviorism retained fewer and fewer adherents. They were

confronted with a broader movement that wanted the internal workings of the mind to be the main topic for researchers, and this movement eventually replaced behaviorism as the dominant theory in the field. As the cognitive revolution took hold, cognition became, and remains, a central feature of much work in social psychology.

The continuing debate about Festinger's text centers on the process that directly causes attitude and behavioral change. There are two major interpretations. One is the belief of Joel Cooper and other scholars that discomfort directly leads to the behavioral and attitude changes that are seen in much cognitive dissonance research. The other argument is similar to Festinger's original proposal—that cognitive inconsistency* is necessary for attempts to reduce dissonance. This is the belief of researchers such as Eddie Harmon-Jones,* and there is support for the claim. The different sides of the debate, however, disagree on only a few points; both accept much of the foundation of Festinger's original theory.

Festinger, meanwhile, welcomed the debate. Cooper, recalling an address Festinger gave in 1987, wrote: "Festinger explained that he had left the field of social psychology in part because he felt so wedded to his statement of dissonance theory that, if he stayed in the field, he would have ended up defending every word of his original statement. And he did not think that was a good thing."[4]

The Continuing Debate

Although behaviorism made way for other approaches in social psychology, several of its principles did survive, and its followers did incorporate some of Festinger's key ideas. Writing in the mid-1980s, Edward E. Jones* noted, "Clearly contemporary approaches that partake of the [behaviorist] legacy have increasingly featured complex cognitive, affective, and motivational processes."[5] Just like the behaviorists, researchers such as the Canadian American psychologist Albert Bandura continued to assume that learning is a

conditioned response,* but they included cognitions as a key part of their evolving approach.

Meanwhile, some of the cognitive consistency theories from the 1950s, such as Heider's balance theory, have found a new influence. Balance theory, for instance, is often applied in marketing research. This was always a likely application, as Heider's theory focused on the interpersonal aspect of cognitive inconsistency*—people want to like what their friends like and tend to dislike what their friends dislike. This principle has been applied to celebrity endorsements, in which a well-liked celebrity is often hired to market a product. In line with balance theory, if an observer likes a celebrity, the observer's opinion of the product is likely to improve.

But Festinger's theories are not incompatible with Heider's. Festinger attempted to explain a much wider range of phenomena than Heider. Much of the controversy that developed after Festinger's publication centered on aspects of his theory that were quite different from that of Heider.

NOTES

1 Joel Cooper, *Cognitive Dissonance: 50 Years of a Classic Theory* (New York: Sage, 2007), 182.

2 Cooper, *50 Years*, 182.

3 Cooper, *50 Years*, 182.

4 Cooper, *50 Years*, 181.

5 Edward E. Jones, "Major Developments in Social Psychology During the Past Five Decades," *The Handbook of Social Psychology* 1 (1985): 71.

WHERE NEXT?

KEY POINTS

- *A Theory of Cognitive Dissonance* is often applied to fields and questions beyond the traditional scope of social psychology.*
- The book and its theory have applications for new areas, such as climate change* denial.
- The text is the original and most thorough work into one of the most influential, popular, and accepted theories in social psychology.

Potential

In marking the 50 years since the publication of Leon Festinger's *A Theory of Cognitive Dissonance*, Eddie Harmon-Jones,* a scholar in the field of cognitive dissonance*, remarked that the "theory has weathered many challenges but still provides much explanatory, integrative, and generative power. It is hoped that recent empirical and theoretical developments within dissonance theory will assist in keeping one of our major theories alive and fertile."[1] But the text and theory also have the potential to influence new areas.

Recently, one of Festinger's former student's, Elliot Aronson,* co-authored the book, *Mistakes Were Made (But Not by Me): Why We Justify Foolish Beliefs, Bad Decisions, and Hurtful Acts.* The book applies the theory of cognitive dissonance to a host of potential new topics and situations—such as marriage, law, science and clinical judgment, memory, and history.[2] In a chapter on wars and conflicts, for instance, he considers the typical tensions between two conflicting parties. He argues that the human instinct to justify our behaviors—a common

> **❝One of the fascinating aspects of cognitive dissonance is that it often helps us make sense out of non-obvious events. ❞**
>
> Joel Cooper, *Cognitive dissonance: 50 Years of a Classic Theory*

technique for dissonance reduction—often serves as an obstacle to conflict resolution.

Aronson's interview data highlights how attempts at dissonance reduction can make conflicts worse: "When we construct narratives that 'make sense,' however, we do so in a self-serving way. Perpetrators are motivated to reduce their moral culpability; victims are motivated to maximize their moral blamelessness... In their narratives, perpetrators drew on different ways to reduce the dissonance caused by realizing they did something wrong. The first, naturally, was to say they did nothing wrong at all: 'I lied to him, but it was only to protect his feelings.' 'Yeah, I took that bracelet from my sister, but it was originally mine, anyway.' Only a few perpetrators admitted that their behavior was immoral or deliberately hurtful or malicious. Most said their offending behavior was justifiable."[3]

Future Directions

Cognitive dissonance will undoubtedly continue to draw interest from social psychologists. However, the most interesting advances in the theory may come from researchers in other fields as they apply the theory to new contexts. Sometimes these contexts may themselves be new—unknown during Festinger's life.

For instance, researchers have recently applied the theory to the public policy of climate change. Several researchers have considered the role that cognitive dissonance may play in climate change denial. Despite a consensus among climate scientists that Earth's climate is changing due to human-induced causes, many non-scientists refute

these conclusions. Some researchers have questioned whether this denial is a result of science illiteracy. However, recent work has found that science illiteracy is not a meaningful predictor of climate change denial. Instead, much of this denial is the result of an effect that has its roots in cognitive dissonance.[4]

The authors of this paper found that people who were suspicious of governmental intervention could be predicted to show climate denial. "Such people intuitively perceive that widespread acceptance of such risks would license restrictions on commerce and industry," they noted.[5] The authors argued that denial reduces dissonance that climate change is occurring, in the face of a belief that governments should not have the power to restrict industries that cause climate change.

This is but one instance of the theory benefiting another academic field, as well as relating to an issue that had not yet emerged during Festinger's lifetime.

Summary

The dominant theory in American psychology until the 1950s was behaviorism*—concerned only with observable behaviors, and having no interest in mental processes. The theory that replaced it took the opposite approach. The cognitive revolution* placed cognition* at the forefront of research in many areas of psychology and other social sciences. Festinger, with his key text, *A Theory of Cognitive Dissonance*, was an early central character in this movement.

Even as researchers were beginning to investigate cognition in the 1950s, nearly all believed that cognition influenced behavior. Festinger showed that the reverse was also true: that our behaviors have the ability to influence our cognitions. They do so, first, by causing dissonance and, second, by driving attitude change to displace that discomforting dissonance. Although the psychological need for cognitive consistency,* including justifying decisions after they have been taken, was not new, Festinger built a framework

around research on psychological consistency. Moreover, his theory put the question in a highly flexible and testable form that has generated research for decades.

Social psychologists routinely praise the text and theory as one of the most influential, productive, important, and compelling works in the history of the field. Its reach has extended well beyond the discipline from which it grew, thousands of articles in enormously wide-ranging fields—anthropology, economics, political science, law, management, and sociology—have looked to apply the theory to a truly diverse range of situations.

NOTES

1 Eddie Harmon-Jones and Cindy Harmon-Jones, "Cognitive Dissonance Theory After 50 Years of Development," *Zeitschrift für Sozialpsychologie* 38, no. 1 (2007): 14.

2 Carol Tavris and Elliot Aronson. *Mistakes Were Made (But Not by Me): Why We Justify Foolish Beliefs, Bad Decisions, and Hurtful Acts* (Orlando, FL: Houghton Mifflin Harcourt, 2008).

3 Tavris, *Mistakes*, 193–4.

4 Dan M. Kahan, et al, "The Polarizing Impact of Science Literacy and Numeracy on Perceived Climate Change Risks," *Nature Climate Change* 2, no.10 (2012): 732–5.

5 Kahan, *Climate*, 732.

GLOSSARY

GLOSSARY OF TERMS

Archaeology: the study of past human activity through the collection and examination of surviving artifacts, materials, and environments.

Balance theory: a theory proposed by Fritz Heider* arguing for a human preference for cognitive consistency, particularly between feelings toward people and opinions of objects.

Behaviorism/Behaviorist: a major theory of learning that dominated psychology throughout the twentieth century, particularly in the middle of the century. The theory tended to view cognitive factors (that is, thinking) as less relevant to behavior, preferring instead the study of observable behaviors.

Climate change: changes in the planet's weather systems that last for extended periods of time.

Cognitive/Cognition: all mental abilities and processes associated with knowledge. The term includes memory, attention, problem-solving, learning, and others.

Cognitive dissonance: the discomfort aroused when people have cognitions and behaviors that are inconsistent with, or dissonant from, each other.

Cognitive psychology/psychologist: an area of psychology that examines basic mental processes such as memory, language, attention, and perception.

Cognitive revolution: the name of a broad movement beginning in the 1950s in several fields, such as psychology, anthropology and

linguistics. This movement focused on studying the internal thoughts, attitudes, motivations, and values that people use to make sense of and interact with the world.

Conditioned response: an integral mechanism through which, according to behaviorists, learning occurs. It is a behavior that is learned through association with other events. For instance, people may develop taste aversions—a conditioned response—to particular foods if they previously got sick around the same time that they ate those same foods.

Cognitive consistency/inconsistency theories: theories that propose people have a preference for consistency over inconsistency between various aspects of their self—cognitions, behaviors, and so on. Balance theory and the theory of cognitive dissonance are two popular examples of consistency theories.

Consonant: consistency between two psychological elements (cognitions or behaviors).

Cult: a social or religious group that is classified as abnormal or deviant.

Decision-making: the cognitive process that results in the selection of one option among numerous alternatives.

Dissonant/dissonance: a term used by Festinger to refer to inconsistency between two psychological elements (cognitions and behaviors).

Efference: signals from the body's central nervous system to its motor system.

Fascism: a philosophy or governmental system based on extreme political, social, and economic ideologies that center on authoritarianism, nationalism, and conservatism.

Forced compliance: the forcing by a person in a powerful position of someone with less power to make statements or perform acts that violate his or her private beliefs.

Gestalt psychology: a holistic approach proposing that perception is the product of complex interactions among various stimuli. Opposing behaviorists, Gestalt psychologists believe that cognitive processes are organized and that they are the key to understanding psychology.

Great Depression: the most significant economic recession in American history, beginning in 1929 and lasting through much of the 1930s.

HIV: the human immunodeficiency virus that causes AIDS.

Individualistic culture: a culture where people think of themselves more as individuals than as members of a group.

Learning theories: (in this context) theories that most learning occurs due to the principles of behaviorism, such as conditioned responses and reinforcement.

Metatheoretical: concerning theories about other theories.

Moderator: a statistic term referring to a third variable that alters the relationship between two other variables.

Nazis/Nazism: the extremely right-wing National Socialist Party that ruled Germany before and during World War II.

Neuroscience: the biological study of the nervous system.

Rationalizer/rationalization: a person who excuses, or the act of excusing, controversial or illogical cognitions or behaviors as acceptable or logical.

Reductionism: attempts to reduce the explanations for psychological phenomena to the most basic of causes, through physics and chemistry.

Reinforcement: a principle component of behaviorism. It refers to a consequence (getting a good grade, for example) that strengthens an association between behavior (say, studying) and a stimulus or cause (knowing a test is upcoming).

Self-perception theory: a theory developed by Daryl Bem★ that asserts that when people have undeveloped cognitions, they infer their attitudes by observing their own behavior.

Social cognition: the use of cognitive psychology approaches, methods, and theorizing of human memory and information processing to study social phenomena.

Social comparison: the proposition by Leon Festinger that in people's drive to accurately evaluate themselves, they often compare themselves to others.

Social psychology: the study of how people's cognitions and behaviors are influence by their social surroundings.

Visual perception: the use of information contained in visible light and through one's sight to understand and interpret the environment around oneself.

Watergate: the name of a building in Washington, DC, containing the offices of the national headquarters of the US Democratic Party, which people connected with the Nixon administration burgled on June 17, 1972. "Watergate" became the umbrella term for the 1972–3 scandal that brought down the presidency of Richard Nixon.

World War II (1939–45): a global conflict fought between the Axis Powers (Germany, Italy, and Japan) and the victorious Allied Powers (United Kingdom and its colonies, the former Soviet Union, and the United States).

PEOPLE MENTIONED IN THE TEXT

Elliot Aronson (b. 1932) is an American social psychologist and former student of Leon Festinger. He is well known for his work on cognitive dissonance.

Albert Bandura (b. 1925) is a Canadian American psychologist and emeritus professor at Stanford University. He is known for his work on social learning theory and self-efficacy.

Frederic C. Bartlett (1886–1969) was a British psychologist and professor of experimental psychology at the University of Cambridge. He influenced the formation of cognitive psychology and the cognitive revolution.

Daryl Bem (b. 1938) is an American social psychologist and professor emeritus at Cornell University. He is known for his work on self-perception theory and its role in attitude formation and change.

Jerome Bruner (b. 1915) is a cognitive, developmental, and educational psychologist and an influential founder of cognitive psychology and the cognitive revolution.

J. Merrill Carlsmith (1936–84) was an American social psychologist and collaborator with Leon Festinger on the topic of cognitive dissonance.

Joel Cooper (b. 1943) is an American social psychologist and professor at Princeton University. He is known for his work on cognitive dissonance and attitude change.

Russell Fazio (b. 1952) is an American social and cognitive psychologist and professor at Ohio State University. He is known for his research on attitude formation and change.

Sigmund Freud (1856–1939) was an Austrian neurologist and psychologist and the founder of psychoanalysis.

Gerald Ford (1913–2006) was the 38th president of the United States. He had served as a member of the US House of Representatives before Richard Nixon selected him to be his running mate in the 1972 presidential election. When Nixon resigned the presidency in August 1974, Ford became president, but he subsequently lost the 1976 election to Jimmy Carter.

Michael S. Gazzaniga (b. 1939) is an American cognitive neuroscientist and psychobiologist and professor at the University of California at Santa Barbara. He is well known for his work studying brain-damaged patients and as an early influential scholar of neuroscience.

Eddie Harmon-Jones is an American social psychology and professor at the University of New South Wales. He is known for his research on cognitive dissonance.

Fritz Heider (1896–1988) is an Austrian psychologist associated with Gestalt psychology and known for his work on balance theory and attribution theory.

Edward E. Jones (1927–93) was an American social psychologist known for his research on attribution theories.

Kurt Lewin (1890–1947) was a German American psychologist and

founder of social psychology. He is renowned for his work on group
dynamics and applied psychology.

Darwyn E. Linder is an American social psychologist known for his
work on attitude formation and change.

Judson Mills (1932–2008) was an American social psychologist. He
was a student of Leon Festinger and researcher of cognitive dissonance.

Richard Nixon (1913–94) was the 37th president of the United
States. He is the only US president to resign from office, following a
political scandal and declining support for American military
involvement in Vietnam.

Charles E. Osgood (1916–91) was an American psychologist
known for his work examining the emotional connotation of words
and phrases.

Milton Rosenberg (b. 1925) is an American social psychology and
emeritus professor at the University of Chicago. He is well known for
his work on cognitive dissonance and attitude change.

Stanley Schachter (1922–97) was an American social psychologist
and student of Leon Festinger known for his theory of emotion.

B. F. Skinner (1904–90) was an American psychologist, philosopher
and author. He was one of the founders of psychological behaviorism.

Percy Tannenbaum (1927–2009) was a Canadian
communications researcher known for his work on the social
psychology of communication.

Henri Zukier is a social psychologist and professor at the New School for Social Research. He is well known for his research into social cognition.

WORKS CITED

WORKS CITED

Aronson, Elliot, and Judson Mills. "The Effect of Severity of Initiation on Liking for a Group." *The Journal of Abnormal and Social Psychology* 59, no. 2 (1959): 177 81.

Bem, Daryl J. "Self-perception: An Alternative Interpretation of Cognitive Dissonance Phenomena." *Psychological Review* 74, no.3 (1967): 183–200.

Cooper, Joel. *Cognitive Dissonance: 50 Years of a Classic Theory.* London: Sage, 2007.

Festinger, Leon. "A Theory of Social Comparison Processes." *Human Relations* 7, no. 2 (1954): 117–40.

A Theory of Cognitive Dissonance. Stanford, CA: Stanford University Press, 1962.

"Cognitive Dissonance." *Scientific American* 207, no. 4 (1962), 93–107.

"Looking backward." In *Retrospections on Social Psychology.* New York: Oxford University Press, 1980.

The Human Legacy. New York: Columbia University Press, 1983.

Festinger, Leon, and James M. Carlsmith. "Cognitive Consequences of Forced Compliance." *The Journal of Abnormal and Social Psychology* 58, no. 2 (1959): 203–10.

Gazzaniga, Michael S. "Leon Festinger: Lunch with Leon." *Perspectives on Psychological Science* 1, no. 1 (2006): 89–94.

Haggbloom, Steven J., Renee Warnick, Jason E. Warnick, Vinessa K. Jones,

Gary L. Yarbrough, Tenea M. Russell, Chris M. Borecky et al. "The 100 Most Eminent Psychologists of the 20th Century." *Review of General Psychology* 6, no. 2 (2002): 139–52.

Harmon-Jones, Eddie, and Cindy Harmon-Jones. "Cognitive Dissonance Theory After 50 Years of Development." *Zeitschrift für Sozialpsychologie* 38, no.1 (2007): 7–16.

Harvey, O. J., and Robert Ware. "Personality Differences in Dissonance Resolution." *Journal of Personality and Social Psychology* 7, no. 2 (1967): 227–30.

Heider, Fritz. *The Psychology of Interpersonal Relations.* Hillsdale, NJ: Psychology Press, 1958.

Hunt, Martin F., and Gerald R. Miller. "Open- and Closed-mindedness, Belief-Discrepant Communication Behavior, and Tolerance for Cognitive Inconsistency." *Journal of Personality and Social Psychology* 8, no.1 (1968): 35-7.

Jones, Edward E. "Major Developments in Social Psychology During the Past Five Decades." *The Handbook of Social Psychology* 1 (1985): 47–107.

Kahan, Dan M., Ellen Peters, Maggie Wittlin, Paul Slovic, Lisa Larrimore Ouellette, Donald Braman, and Gregory Mandel. "The Polarizing Impact of Science Literacy and Numeracy on Perceived Climate Change Risks." *Nature Climate Change* 2, no.10 (2012): 732–5.

Osgood, Charles E., and Percy H. Tannenbaum. "The Principle of Congruity in the Prediction of Attitude Change." Psychological Review 62, no.1 (1955): 42–55.

Schachter, Stanley. "Leon Festinger." *Biographical Memoirs* 64 (1994): 99–110.

Skinner, Burrhus Frederic. *About Behaviorism*. New York: Vintage, 1974.

Tavris, Carol, and Elliot Aronson. *Mistakes Were Made (But Not By Me): Why We Justify Foolish Beliefs, Bad Decisions, and Hurtful Acts*. Orlando, FL: Houghton Mifflin Harcourt, 2008.

Zukier, H. "Introduction." *Extending Psychological Frontiers: Selected Works of Leon Festinger*, edited by Stanley Schachter and Michael Gazzaniga, xi–xxiv. New York: Sage, 1989.

THE MACAT LIBRARY
BY DISCIPLINE

The Macat Library By Discipline

AFRICANA STUDIES

Chinua Achebe's *An Image of Africa: Racism in Conrad's Heart of Darkness*
W. E. B. Du Bois's *The Souls of Black Folk*
Zora Neale Huston's *Characteristics of Negro Expression*
Martin Luther King Jr's *Why We Can't Wait*
Toni Morrison's *Playing in the Dark: Whiteness in the American Literary Imagination*

ANTHROPOLOGY

Arjun Appadurai's *Modernity at Large: Cultural Dimensions of Globalisation*
Philippe Ariès's *Centuries of Childhood*
Franz Boas's *Race, Language and Culture*
Kim Chan & Renée Mauborgne's *Blue Ocean Strategy*
Jared Diamond's *Guns, Germs & Steel: the Fate of Human Societies*
Jared Diamond's *Collapse: How Societies Choose to Fail or Survive*
E. E. Evans-Pritchard's *Witchcraft, Oracles and Magic Among the Azande*
James Ferguson's *The Anti-Politics Machine*
Clifford Geertz's *The Interpretation of Cultures*
David Graeber's *Debt: the First 5000 Years*
Karen Ho's *Liquidated: An Ethnography of Wall Street*
Geert Hofstede's *Culture's Consequences: Comparing Values, Behaviors, Institutes and Organizations across Nations*
Claude Lévi-Strauss's *Structural Anthropology*
Jay Macleod's *Ain't No Makin' It: Aspirations and Attainment in a Low-Income Neighborhood*
Saba Mahmood's *The Politics of Piety: The Islamic Revival and the Feminist Subject*
Marcel Mauss's *The Gift*

BUSINESS

Jean Lave & Etienne Wenger's *Situated Learning*
Theodore Levitt's *Marketing Myopia*
Burton G. Malkiel's *A Random Walk Down Wall Street*
Douglas McGregor's *The Human Side of Enterprise*
Michael Porter's *Competitive Strategy: Creating and Sustaining Superior Performance*
John Kotter's *Leading Change*
C. K. Prahalad & Gary Hamel's *The Core Competence of the Corporation*

CRIMINOLOGY

Michelle Alexander's *The New Jim Crow: Mass Incarceration in the Age of Colorblindness*
Michael R. Gottfredson & Travis Hirschi's *A General Theory of Crime*
Richard Herrnstein & Charles A. Murray's *The Bell Curve: Intelligence and Class Structure in American Life*
Elizabeth Loftus's *Eyewitness Testimony*
Jay Macleod's *Ain't No Makin' It: Aspirations and Attainment in a Low-Income Neighborhood*
Philip Zimbardo's *The Lucifer Effect*

ECONOMICS

Janet Abu-Lughod's *Before European Hegemony*
Ha-Joon Chang's *Kicking Away the Ladder*
David Brion Davis's *The Problem of Slavery in the Age of Revolution*
Milton Friedman's *The Role of Monetary Policy*
Milton Friedman's *Capitalism and Freedom*
David Graeber's *Debt: the First 5000 Years*
Friedrich Hayek's *The Road to Serfdom*
Karen Ho's *Liquidated: An Ethnography of Wall Street*

John Maynard Keynes's *The General Theory of Employment, Interest and Money*
Charles P. Kindleberger's *Manias, Panics and Crashes*
Robert Lucas's *Why Doesn't Capital Flow from Rich to Poor Countries?*
Burton G. Malkiel's *A Random Walk Down Wall Street*
Thomas Robert Malthus's *An Essay on the Principle of Population*
Karl Marx's *Capital*
Thomas Piketty's *Capital in the Twenty-First Century*
Amartya Sen's *Development as Freedom*
Adam Smith's *The Wealth of Nations*
Nassim Nicholas Taleb's *The Black Swan: The Impact of the Highly Improbable*
Amos Tversky's & Daniel Kahneman's *Judgment under Uncertainty: Heuristics and Biases*
Mahbub Ul Haq's *Reflections on Human Development*
Max Weber's *The Protestant Ethic and the Spirit of Capitalism*

FEMINISM AND GENDER STUDIES

Judith Butler's *Gender Trouble*
Simone De Beauvoir's *The Second Sex*
Michel Foucault's *History of Sexuality*
Betty Friedan's *The Feminine Mystique*
Saba Mahmood's *The Politics of Piety: The Islamic Revival and the Feminist Subject*
Joan Wallach Scott's *Gender and the Politics of History*
Mary Wollstonecraft's *A Vindication of the Rights of Woman*
Virginia Woolf's *A Room of One's Own*

GEOGRAPHY

The Brundtland Report's *Our Common Future*
Rachel Carson's *Silent Spring*
Charles Darwin's *On the Origin of Species*
James Ferguson's *The Anti-Politics Machine*
Jane Jacobs's *The Death and Life of Great American Cities*
James Lovelock's *Gaia: A New Look at Life on Earth*
Amartya Sen's *Development as Freedom*
Mathis Wackernagel & William Rees's *Our Ecological Footprint*

HISTORY

Janet Abu-Lughod's *Before European Hegemony*
Benedict Anderson's *Imagined Communities*
Bernard Bailyn's *The Ideological Origins of the American Revolution*
Hanna Batatu's *The Old Social Classes And The Revolutionary Movements Of Iraq*
Christopher Browning's *Ordinary Men: Reserve Police Batallion 101 and the Final Solution in Poland*
Edmund Burke's *Reflections on the Revolution in France*
William Cronon's *Nature's Metropolis: Chicago And The Great West*
Alfred W. Crosby's *The Columbian Exchange*
Hamid Dabashi's *Iran: A People Interrupted*
David Brion Davis's *The Problem of Slavery in the Age of Revolution*
Nathalie Zemon Davis's *The Return of Martin Guerre*
Jared Diamond's *Guns, Germs & Steel: the Fate of Human Societies*
Frank Dikotter's *Mao's Great Famine*
John W Dower's *War Without Mercy: Race And Power In The Pacific War*
W. E. B. Du Bois's *The Souls of Black Folk*
Richard J. Evans's *In Defence of History*
Lucien Febvre's *The Problem of Unbelief in the 16th Century*
Sheila Fitzpatrick's *Everyday Stalinism*

The Macat Library By Discipline

Eric Foner's *Reconstruction: America's Unfinished Revolution, 1863-1877*
Michel Foucault's *Discipline and Punish*
Michel Foucault's *History of Sexuality*
Francis Fukuyama's *The End of History and the Last Man*
John Lewis Gaddis's *We Now Know: Rethinking Cold War History*
Ernest Gellner's *Nations and Nationalism*
Eugene Genovese's *Roll, Jordan, Roll: The World the Slaves Made*
Carlo Ginzburg's *The Night Battles*
Daniel Goldhagen's *Hitler's Willing Executioners*
Jack Goldstone's *Revolution and Rebellion in the Early Modern World*
Antonio Gramsci's *The Prison Notebooks*
Alexander Hamilton, John Jay & James Madison's *The Federalist Papers*
Christopher Hill's *The World Turned Upside Down*
Carole Hillenbrand's *The Crusades: Islamic Perspectives*
Thomas Hobbes's *Leviathan*
Eric Hobsbawm's *The Age Of Revolution*
John A. Hobson's *Imperialism: A Study*
Albert Hourani's *History of the Arab Peoples*
Samuel P. Huntington's *The Clash of Civilizations and the Remaking of World Order*
C. L. R. James's *The Black Jacobins*
Tony Judt's *Postwar: A History of Europe Since 1945*
Ernst Kantorowicz's *The King's Two Bodies: A Study in Medieval Political Theology*
Paul Kennedy's *The Rise and Fall of the Great Powers*
Ian Kershaw's *The "Hitler Myth": Image and Reality in the Third Reich*
John Maynard Keynes's *The General Theory of Employment, Interest and Money*
Charles P. Kindleberger's *Manias, Panics and Crashes*
Martin Luther King Jr's *Why We Can't Wait*
Henry Kissinger's *World Order: Reflections on the Character of Nations and the Course of History*
Thomas Kuhn's *The Structure of Scientific Revolutions*
Georges Lefebvre's *The Coming of the French Revolution*
John Locke's *Two Treatises of Government*
Niccolò Machiavelli's *The Prince*
Thomas Robert Malthus's *An Essay on the Principle of Population*
Mahmood Mamdani's *Citizen and Subject: Contemporary Africa And The Legacy Of Late Colonialism*
Karl Marx's *Capital*
Stanley Milgram's *Obedience to Authority*
John Stuart Mill's *On Liberty*
Thomas Paine's *Common Sense*
Thomas Paine's *Rights of Man*
Geoffrey Parker's *Global Crisis: War, Climate Change and Catastrophe in the Seventeenth Century*
Jonathan Riley-Smith's *The First Crusade and the Idea of Crusading*
Jean-Jacques Rousseau's *The Social Contract*
Joan Wallach Scott's *Gender and the Politics of History*
Theda Skocpol's *States and Social Revolutions*
Adam Smith's *The Wealth of Nations*
Timothy Snyder's *Bloodlands: Europe Between Hitler and Stalin*
Sun Tzu's *The Art of War*
Keith Thomas's *Religion and the Decline of Magic*
Thucydides's *The History of the Peloponnesian War*
Frederick Jackson Turner's *The Significance of the Frontier in American History*
Odd Arne Westad's *The Global Cold War: Third World Interventions And The Making Of Our Times*

LITERATURE

Chinua Achebe's *An Image of Africa: Racism in Conrad's Heart of Darkness*
Roland Barthes's *Mythologies*
Homi K. Bhabha's *The Location of Culture*
Judith Butler's *Gender Trouble*
Simone De Beauvoir's *The Second Sex*
Ferdinand De Saussure's *Course in General Linguistics*
T. S. Eliot's *The Sacred Wood: Essays on Poetry and Criticism*
Zora Neale Huston's *Characteristics of Negro Expression*
Toni Morrison's *Playing in the Dark: Whiteness in the American Literary Imagination*
Edward Said's *Orientalism*
Gayatri Chakravorty Spivak's *Can the Subaltern Speak?*
Mary Wollstonecraft's *A Vindication of the Rights of Women*
Virginia Woolf's *A Room of One's Own*

PHILOSOPHY

Elizabeth Anscombe's *Modern Moral Philosophy*
Hannah Arendt's *The Human Condition*
Aristotle's *Metaphysics*
Aristotle's *Nicomachean Ethics*
Edmund Gettier's *Is Justified True Belief Knowledge?*
Georg Wilhelm Friedrich Hegel's *Phenomenology of Spirit*
David Hume's *Dialogues Concerning Natural Religion*
David Hume's *The Enquiry for Human Understanding*
Immanuel Kant's *Religion within the Boundaries of Mere Reason*
Immanuel Kant's *Critique of Pure Reason*
Søren Kierkegaard's *The Sickness Unto Death*
Søren Kierkegaard's *Fear and Trembling*
C. S. Lewis's *The Abolition of Man*
Alasdair MacIntyre's *After Virtue*
Marcus Aurelius's *Meditations*
Friedrich Nietzsche's *On the Genealogy of Morality*
Friedrich Nietzsche's *Beyond Good and Evil*
Plato's *Republic*
Plato's *Symposium*
Jean-Jacques Rousseau's *The Social Contract*
Gilbert Ryle's *The Concept of Mind*
Baruch Spinoza's *Ethics*
Sun Tzu's *The Art of War*
Ludwig Wittgenstein's *Philosophical Investigations*

POLITICS

Benedict Anderson's *Imagined Communities*
Aristotle's *Politics*
Bernard Bailyn's *The Ideological Origins of the American Revolution*
Edmund Burke's *Reflections on the Revolution in France*
John C. Calhoun's *A Disquisition on Government*
Ha-Joon Chang's *Kicking Away the Ladder*
Hamid Dabashi's *Iran: A People Interrupted*
Hamid Dabashi's *Theology of Discontent: The Ideological Foundation of the Islamic Revolution in Iran*
Robert Dahl's *Democracy and its Critics*
Robert Dahl's *Who Governs?*
David Brion Davis's *The Problem of Slavery in the Age of Revolution*

The Macat Library By Discipline

Alexis De Tocqueville's *Democracy in America*
James Ferguson's *The Anti-Politics Machine*
Frank Dikotter's *Mao's Great Famine*
Sheila Fitzpatrick's *Everyday Stalinism*
Eric Foner's *Reconstruction: America's Unfinished Revolution, 1863-1877*
Milton Friedman's *Capitalism and Freedom*
Francis Fukuyama's *The End of History and the Last Man*
John Lewis Gaddis's *We Now Know: Rethinking Cold War History*
Ernest Gellner's *Nations and Nationalism*
David Graeber's *Debt: the First 5000 Years*
Antonio Gramsci's *The Prison Notebooks*
Alexander Hamilton, John Jay & James Madison's *The Federalist Papers*
Friedrich Hayek's *The Road to Serfdom*
Christopher Hill's *The World Turned Upside Down*
Thomas Hobbes's *Leviathan*
John A. Hobson's *Imperialism: A Study*
Samuel P. Huntington's *The Clash of Civilizations and the Remaking of World Order*
Tony Judt's *Postwar: A History of Europe Since 1945*
David C. Kang's *China Rising: Peace, Power and Order in East Asia*
Paul Kennedy's *The Rise and Fall of Great Powers*
Robert Keohane's *After Hegemony*
Martin Luther King Jr.'s *Why We Can't Wait*
Henry Kissinger's *World Order: Reflections on the Character of Nations and the Course of History*
John Locke's *Two Treatises of Government*
Niccolò Machiavelli's *The Prince*
Thomas Robert Malthus's *An Essay on the Principle of Population*
Mahmood Mamdani's *Citizen and Subject: Contemporary Africa And The Legacy Of Late Colonialism*
Karl Marx's *Capital*
John Stuart Mill's *On Liberty*
John Stuart Mill's *Utilitarianism*
Hans Morgenthau's *Politics Among Nations*
Thomas Paine's *Common Sense*
Thomas Paine's *Rights of Man*
Thomas Piketty's *Capital in the Twenty-First Century*
Robert D. Putman's *Bowling Alone*
John Rawls's *Theory of Justice*
Jean-Jacques Rousseau's *The Social Contract*
Theda Skocpol's *States and Social Revolutions*
Adam Smith's *The Wealth of Nations*
Sun Tzu's *The Art of War*
Henry David Thoreau's *Civil Disobedience*
Thucydides's *The History of the Peloponnesian War*
Kenneth Waltz's *Theory of International Politics*
Max Weber's *Politics as a Vocation*
Odd Arne Westad's *The Global Cold War: Third World Interventions And The Making Of Our Times*

POSTCOLONIAL STUDIES

Roland Barthes's *Mythologies*
Frantz Fanon's *Black Skin, White Masks*
Homi K. Bhabha's *The Location of Culture*
Gustavo Gutiérrez's *A Theology of Liberation*
Edward Said's *Orientalism*
Gayatri Chakravorty Spivak's *Can the Subaltern Speak?*

PSYCHOLOGY

Gordon Allport's *The Nature of Prejudice*
Alan Baddeley & Graham Hitch's *Aggression: A Social Learning Analysis*
Albert Bandura's *Aggression: A Social Learning Analysis*
Leon Festinger's *A Theory of Cognitive Dissonance*
Sigmund Freud's *The Interpretation of Dreams*
Betty Friedan's *The Feminine Mystique*
Michael R. Gottfredson & Travis Hirschi's *A General Theory of Crime*
Eric Hoffer's *The True Believer: Thoughts on the Nature of Mass Movements*
William James's *Principles of Psychology*
Elizabeth Loftus's *Eyewitness Testimony*
A. H. Maslow's *A Theory of Human Motivation*
Stanley Milgram's *Obedience to Authority*
Steven Pinker's *The Better Angels of Our Nature*
Oliver Sacks's *The Man Who Mistook His Wife For a Hat*
Richard Thaler & Cass Sunstein's *Nudge: Improving Decisions About Health, Wealth and Happiness*
Amos Tversky's *Judgment under Uncertainty: Heuristics and Biases*
Philip Zimbardo's *The Lucifer Effect*

SCIENCE

Rachel Carson's *Silent Spring*
William Cronon's *Nature's Metropolis: Chicago And The Great West*
Alfred W. Crosby's *The Columbian Exchange*
Charles Darwin's *On the Origin of Species*
Richard Dawkin's *The Selfish Gene*
Thomas Kuhn's *The Structure of Scientific Revolutions*
Geoffrey Parker's *Global Crisis: War, Climate Change and Catastrophe in the Seventeenth Century*
Mathis Wackernagel & William Rees's *Our Ecological Footprint*

SOCIOLOGY

Michelle Alexander's *The New Jim Crow: Mass Incarceration in the Age of Colorblindness*
Gordon Allport's *The Nature of Prejudice*
Albert Bandura's *Aggression: A Social Learning Analysis*
Hanna Batatu's *The Old Social Classes And The Revolutionary Movements Of Iraq*
Ha-Joon Chang's *Kicking Away the Ladder*
W. E. B. Du Bois's *The Souls of Black Folk*
Émile Durkheim's *On Suicide*
Frantz Fanon's *Black Skin, White Masks*
Frantz Fanon's *The Wretched of the Earth*
Eric Foner's *Reconstruction: America's Unfinished Revolution, 1863-1877*
Eugene Genovese's *Roll, Jordan, Roll: The World the Slaves Made*
Jack Goldstone's *Revolution and Rebellion in the Early Modern World*
Antonio Gramsci's *The Prison Notebooks*
Richard Herrnstein & Charles A Murray's *The Bell Curve: Intelligence and Class Structure in American Life*
Eric Hoffer's *The True Believer: Thoughts on the Nature of Mass Movements*
Jane Jacobs's *The Death and Life of Great American Cities*
Robert Lucas's *Why Doesn't Capital Flow from Rich to Poor Countries?*
Jay Macleod's *Ain't No Makin' It: Aspirations and Attainment in a Low Income Neighborhood*
Elaine May's *Homeward Bound: American Families in the Cold War Era*
Douglas McGregor's *The Human Side of Enterprise*
C. Wright Mills's *The Sociological Imagination*

The Macat Library By Discipline

Thomas Piketty's *Capital in the Twenty-First Century*
Robert D. Putman's *Bowling Alone*
David Riesman's *The Lonely Crowd: A Study of the Changing American Character*
Edward Said's *Orientalism*
Joan Wallach Scott's *Gender and the Politics of History*
Theda Skocpol's *States and Social Revolutions*
Max Weber's *The Protestant Ethic and the Spirit of Capitalism*

THEOLOGY

Augustine's *Confessions*
Benedict's *Rule of St Benedict*
Gustavo Gutiérrez's *A Theology of Liberation*
Carole Hillenbrand's *The Crusades: Islamic Perspectives*
David Hume's *Dialogues Concerning Natural Religion*
Immanuel Kant's *Religion within the Boundaries of Mere Reason*
Ernst Kantorowicz's *The King's Two Bodies: A Study in Medieval Political Theology*
Søren Kierkegaard's *The Sickness Unto Death*
C. S. Lewis's *The Abolition of Man*
Saba Mahmood's *The Politics of Piety: The Islamic Revival and the Feminist Subjec*t
Baruch Spinoza's *Ethics*
Keith Thomas's *Religion and the Decline of Magic*

COMING SOON

Chris Argyris's *The Individual and the Organisation*
Seyla Benhabib's *The Rights of Others*
Walter Benjamin's *The Work Of Art in the Age of Mechanical Reproduction*
John Berger's *Ways of Seeing*
Pierre Bourdieu's *Outline of a Theory of Practice*
Mary Douglas's *Purity and Danger*
Roland Dworkin's *Taking Rights Seriously*
James G. March's *Exploration and Exploitation in Organisational Learning*
Ikujiro Nonaka's *A Dynamic Theory of Organizational Knowledge Creation*
Griselda Pollock's *Vision and Difference*
Amartya Sen's *Inequality Re-Examined*
Susan Sontag's *On Photography*
Yasser Tabbaa's *The Transformation of Islamic Art*
Ludwig von Mises's *Theory of Money and Credit*

Macat Disciplines

Access the greatest ideas and thinkers across entire disciplines, including

AFRICANA STUDIES

Chinua Achebe's *An Image of Africa: Racism in Conrad's Heart of Darkness*

W. E. B. Du Bois's *The Souls of Black Folk*

Zora Neale Hurston's *Characteristics of Negro Expression*

Martin Luther King Jr.'s *Why We Can't Wait*

Toni Morrison's *Playing in the Dark: Whiteness in the American Literary Imagination*

Macat Disciplines

Access the greatest ideas and thinkers across entire disciplines, including

FEMINISM, GENDER AND QUEER STUDIES

Simone De Beauvoir's
The Second Sex

Michel Foucault's
History of Sexuality

Betty Friedan's
The Feminine Mystique

Saba Mahmood's
*The Politics of Piety:
The Islamic Revival and
the Feminist Subject*

Joan Wallach Scott's
*Gender and the
Politics of History*

Mary Wollstonecraft's
*A Vindication of the
Rights of Woman*

Virginia Woolf's
A Room of One's Own

Judith Butler's
Gender Trouble

Macat analyses are available from all good bookshops and libraries.

Access hundreds of analyses through one, multimedia tool.

Join free for one month **library.macat.com**

Macat Disciplines

Access the greatest ideas and thinkers across entire disciplines, including

MACAT

INEQUALITY

Ha-Joon Chang's, *Kicking Away the Ladder*

David Graeber's, *Debt: The First 5000 Years*

Robert E. Lucas's, *Why Doesn't Capital Flow from Rich To Poor Countries?*

Thomas Piketty's, *Capital in the Twenty-First Century*

Amartya Sen's, *Inequality Re-Examined*

Mahbub Ul Haq's, *Reflections on Human Development*

Macat analyses are available from all good bookshops and libraries.

Access hundreds of analyses through one, multimedia tool.
Join free for one month **library.macat.com**

Printed in the United States
by Baker & Taylor Publisher Services